black+whiteley

Barry Dickins in search of Brett

Hardie Grant Books

Published in 2002
by Hardie Grant Books
12 Claremont Street
South Yarra, Victoria 3141, Australia
www.hardiegrant.com.au

National Library of Australia Cataloguing-in-Publication Data:

Dickins, Barry, 1949– .
 Black and Whiteley: Barry Dickins in search of Brett.
 ISBN 1 74064 001 2.
 1. Whiteley, Brett, 1939–1992 – Anecdotes. 2. Painters – Australia –
 Biography. I. Title.
759.994.

Edited by Sally Moss
Cover and text design by Guy Mirabella
Cover photograph by Juno Gemes
Typeset by J & M Typesetting
Printed and bound in Australia by McPherson's Printing Group

10 9 8 7 6 5 4 3 2 1

What is the price of experience?
Do men buy it for a song, or
Wisdom for a dance in the street?
No: it is bought with the price
Of all that a man hath:
His house, his wife, his children.

William Blake, The Four
Zoas, *Night the Second*

acknowledgements

Thanks to all those who helped me to research this book. I enjoyed rambly conversations with Wendy Whiteley, Martin Sharp, Peter Kingston, Keith Looby and his partner April and with many of Brett Whiteley's friends and fellow artists in Sydney. In Melbourne, I listened to the recollections of Asher and Luba Bilu, Ivan Durrant and Stuart Purves. Others I wish to thank are Juno Adamson, David Galloway, Jan Lacey, Sally Lynch, Helen McGeorge, Phil and Paul Maloney, Jenny O'Driscoll, Barry Pearce, Deborah Pearse, Robyn Russell, Michael Sakir, Petra Santry, Anna Schwartz, Margaret Throsby, Phil Tory, Albert Rotstein, Richard Vahl, and Jean Walker and John Spence of the ABC Radio Archives.

Numerous souls so keen to see my vision of Brett Whiteley are to be thanked by me.

Sally Moss, my editor, for brilliantly rejigging the puzzle to fit a solution and for reinterpreting reminiscence to fit the descriptions I wrote to invite the reader ever onward into Whiteley's often bizarre but beautiful pictures.

Julie Pinkham and Sandy Grant for patience with me—and their humour and zest and all that stuff.

Jenny Lee for a great deal of earlier editing and excavation.

This book of feelings is dedicated to the spirit of B.W. himself. I have got him, I think, alive again.

Barry Dickins
Melbourne, 2002

contents

introduction

Now that he's history, Brett Whiteley remains one of the strangest artists the world ever saw. He was just about the only Australian painter to make the grade as a pop superstar and, as such, may well be the last to die in a blurry hunt to recapture some of his own panache. A czar of art, he seemed afraid of nothing except being forgotten. He scrounged for inspiration among mythical artists of Europe, becoming a mosaic Modigliani, a Balmain Rembrandt, a North Shore Leonardo, a Sydney Harbour Francis Bacon … A 'raider of other artists of genius' was one of the many descriptions he applied to himself.

Whiteley is mourned and loathed and missed by more Australian artists than you can poke a stick at. They're still jealous of him. He was incomparable, and he knew it. At twenty-two, he became a household name in London. He was given a one-man show at the Matthiesen Gallery in Bond Street in 1962 and became the youngest painter ever to have a painting acquired by the prestigious Tate Gallery. While painters stuck in Australia sipped anonymity for

acetylene artist

morning tea, the Fleet Street press raved about 'Whiteley the Wonder Boy', dubbing the young expat 'the Shirley Temple of English art'.

Before long, Whiteley was absolutely loaded. Fellowships rained down on him and everything he touched seemed to sell. He won, at some stage or other, every art prize you can win in his native country. In 1978 he took out the Archibald, the Sulman, and the Wynne prizes simultaneously (his second time round for each of them), rocketing past his fellow Sydney artists. There has never been a man so sure of his own talent or—in his words—'memorableness'.

And where did that sureness come from?

He certainly had a pedigree: his sister Frannie wrote in her memoir, 'We learnt aesthetics in the womb.' For some reason all the Whiteleys were born-to-rule genius types without the merest qualm about their blue-blood inheritance. It was a very loving silver spoonful the son and daughter received from Beryl their mum.

Socially, Whiteley had a head start over any other artist in Sydney; he was just so much more prosperous, and his impeccable connections were beyond price or comprehension. A lover of extravagant appearances and possessed of incredible finesse, he made every opening night a happening. Those events were stunning, with music and incense and flowers and exotic foods. There's little of that stylishness at art shows now; dullness seems *de rigueur*. When I hear humourless people reading dreary speeches, I feel a keen nostalgia for Whiteley's spontaneous poetics. He was, in his own view, 'The Man'.

Whiteley was besotted with the drive of Bob Dylan's music and he tried to imitate the hip way Dylan wrote, joked and spoke. He even dressed like Dylan and emulated his Afro hairstyle. When Dylan came to Whiteley's studio in 1986 and held a press conference there, you could hear other artists shaking their heads and muttering, 'How did Whiteley pull *that* off? Is he a mate of Bob's?'

But no one who ever thought of themselves as an artist hit the gas like him. Not just full throttle and full bottle, but full-strength smoking self-destruction. More than a decade after his death, his name still provokes high-voltage contradictions. You chat with a Sydney taxi driver or a ferry-coupon collector at Circular Quay, and they'll have plenty to say about Whiteley and his women, heroin, divorce settlements and ruin, because Whiteley became a tabloid synonym for decadence.

Dirty little junkie is what most tabloid readers think of him, recalling his sordid death. Whiteley the Man is unknown,

really, though his name is flagrantly exploited. Tourists flock to the Art Gallery of New South Wales to gawk at his work, buy a T-shirt with his face silk-screened on it and forget the complicated character he was.

But who was he really? He devoured the history of drawing and painting as students of theology study the Bible. Almost until the end of his frantic life he hung on to drawing as a life raft to fetch him out of the slough of reality, something that he didn't much like or trust. As a child at a joyless country school in Bathurst, New South Wales, he discovered he had a light and comic touch. HB black-lead pencils were his weapon of choice to have a go at the world. When life guaranteed torment, he could sharpen them up and get a kick from drawing. Funny pictures by his own hand eased him into the oases of history, the happy hunting ground of satiric appearances. At the age of just seven, he executed, in a couple of seconds, a picture of men playing cricket that makes a perfect mockery of the game. (Years later, he revisited this infantile drawing and painted a riotous, mural-sized travesty of cricket; after one glance at it, you'd never take cricket seriously again.) All this to escape the sledge-hammering of eye-watering alphabets and times tables, geography, physics and Latin in a boiling-hot, humourless country town a long way from home—which was Northwood in suburban Sydney.

The profoundly bored schoolboy became a man who could snare lighter-than-air objects to distract himself from dreariness and other bothers—his parents' separation, his own

divorce and money nightmares, and his oscillating addiction to heroin and alcohol. There were no divorces in drawing; nor was there upheaval or sin. When he drew, there was only security and innocent pleasure for future fellow-travellers and blinking beholders.

At his brilliant best, he could create anything. He could draw the energy in water, paint fluid underwater sensations of bush creeks, breathe life into clumps of plump berries in his sketchbook. It is this part of his life that I respect most. Here I look up to him, the dedicated artist dipping the pen and the sable brush into the temperamental ink bottle, never flicking the brush in a lazy way, never half-hearted, never hung over, never on acid or dope or crack or heroin or morphine. Imagine him just for a moment without poison, with just the work to lift him out of the dross of existence.

At this stage of his life, in his early thirties, drawing each morning was the balm. But in the 1970s arrives the killer concrete, leading to the wrong conclusion that the art would dry up if he dried out. *Self Portrait in the Studio* (1976) is not him, but it won whoever-he-assumed-he-was the Archibald Prize in 1977. But with the *Jacaranda Tree* (1977) he transcends others to paint as *himself* rather than *selves* and the picture is deliciously honest as well as thoroughly captivating. It's very beautiful.

Wendy gets off the drug in England and he stays or goes hither and yon on it and on it and off it and off it, but who's kidding who, the injector or the drug itself, of itself, as if it were an indomitable demander of oblivion that is perfect

slavedom, pop-star penal servitude. Detachment is the very heart of analysis and one wonders why Wendy and Brett thought they could brief and debrief each other drugged. There's everything except rest when one is so drunken and drugged and to slug it out without rest is not the way to access the unblinking Muse who doesn't read *Time* magazine. Why would anyone take *Time* magazine seriously? Whiteley did. He believed it was the only world contact available.

At one of his shows at Australian Galleries in the 1970s, I was knocked out by a series of unforgettable pictures. Let's see them again in my memory. I can make out water bubbles, frog shadows, convincingly drawn cobwebbed bracken. He did drooping wet mossy fourteenth-century boughs leading to mystical places where frogs reconnoitre. He was just painting the interior of a cold creek somewhere, but he breathed into it watery, inky life. Showed the art lover the way all currents go.

It's some thirty years since I was at that opening. God. My nose is right up to the glass now. Framed pictures I found hard to take in. I wondered then, as I wonder now, like everyone else: how did he do *that*?

ONE DAY IN HIS STUDIO right on the water overlooking Sydney Harbour the painter Peter Kingston excitedly showed me an appalling picture of himself, an etching executed somehow by a very sick man who happened to be what was left of Brett Whiteley.

'Isn't this amazing?' he declared, and I found it rather

5

trying endeavouring to excavate my response because the etching was so weakly drawn that it was nothing more than pitiable. Lamentably, Whiteley couldn't draw any more. He died just after.

'That's me; Brett did it in 1992,' said Mr Kingston, before bounding away to locate a wondrous etching Whiteley had done of a wharf labourer chucking a rope round a pier pole, in the manner of a black and white comic strip artist, something out of Ginger Meggs. He then handed me the etching, saying 'Keep it if you like.'

The last few years of Brett Whiteley's long—when you think of his addiction—life was a worldwide confused search for his abandoned talent. He jetted around the globe looking for it.

I stared at the dreadful drawing in the so-called terrific etching proffered by Peter and thought there and then of the wondrous work wrought from Whiteley's honest, sincere, hard-working student days, bent over silkscreen presses and cluttered workbenches, going to bed just about clasping a battery of bespattered tools to render his visions all the better.

Genius into wastrel. That was his calling card. To under-stand his chaos, you need to study the frisson of his best works. His real friends were the sheets of beautiful, clean cartridge paper, the unminding ink pens, the contented workaday water-colour brushes—the items of sense. It was a lovely, clean world in which to draw breath and abstract your way out of the boredom of suffering and mortality. When it was too late to pick up the pencils and go clean again, then where would he be? In no-man's-land.

In his mid-forties, after a surrealistically unimaginable divorce from Wendy, his partner in notoriety, he spiralled ever downwards, then spent his last few years battling heroin addiction. In the end, it became known that he who had painted the most ferocious fornicating couldn't make it happen. He was a eunuch whispering hoarse farewells to fellow travellers like Ernest Hemingway, who chose a double-barrelled shotgun in the gob to escape sexlessness, offering his brains to a nearby wall. Just like Hemingway, Whiteley was at his wits' end. He felt so betrayed by some of his closest friends that he seemed to go off the human race entirely, preferring the company of Moreton Bay fig trees, dogs and cats—but most of all birds ... he thought of himself spiritually as a bird.

Nightly, Whiteley spoke to birds, his old friends and confessors. Perhaps in his racing mind he expected a chorus of elegantly crooned responses, something to tell him where his talent lay. The most gifted, the most outrageous and flamboyant artist was becoming uninteresting, which is worse than being dead.

His inevitable, almost inspired ruin was finalised in June 1992, when he was found dead in a motel room at Thirroul, just north of Wollongong on the south coast of New South Wales. He had spent several days wiping himself out on a cocktail of methadone and Bell's whisky. He was discovered in a foetal position. Was he heading back to one of these womb homes from long ago, where once there was kindness? Or was he just in excruciating physical pain? During his last days, he

was seen to over-thank complete strangers who had done small things, like say hello to him or perhaps light his smoke or open a door for him when he was too drugged to do it himself.

The corpse was pretty stale when they found him, and the media made a mocking meal of him. There wasn't much by way of regret or heart for someone who had always been the life of the party: a bon vivant, raconteur and source of constant diversion and wonder. He who had entertained dreary journalists was slagged on, mocked, slandered and excoriated by them. This abuse is in part why I wanted to praise him.

But the years have gone by since. Let's take a look at him again. What about his talent before the decline and fall? Shouldn't his voice be heard and his pictures be clearly seen? Does he deserve silence in death after life had its murderous way with him? Maybe it's time we thought about him with just a dash of empathy. He's a mystery well worth unravelling. Why do some people paint him so blackly, so bleakly, while others whitewash their memories of Whiteley?

Whiteley once famously said 'I paint in order to see.' I felt I had to write about him in order to see him, too. I started out objecting to his addiction to alcohol and heroin, but by the time I had listened to people who knew him, I began to appreciate not so much the artist as the character. And, by listening to ordinary people who knew Whiteley, I began to overhear him too, as it were.

He loved talking and was one of the few artists who could express his feelings eloquently and with charm. He spoke

at the speed of thought and he thought with incredible rapidity. Anything he said seemed fascinating. He said radio was his favourite medium, and when you hear tapes of him on the air, you soon understand why. Sometimes he spoke directly and without affectation, in a broad Australian accent; other times he camped it up for his listeners and put on ludicrous voices.

One of his last radio interviews was with ABC broadcaster Margaret Throsby in Sydney not long before he died. Towards the end of their intriguing, offbeat conversation, Throsby realises Whiteley is pretty spaced out, to say the least. With a mixture of bemusement and concern, she says, 'You'd better look after yourself.'

To which Whiteley replies, 'Oh, yes, and how is that to be done?'

This is gallows humour with a highly polished finish. Whiteley knows exactly where he is, and he has a clue where he is off to pretty soon. He did whatever in the world he wanted, and the rest of the world could go to the devil any time they liked. After all, Whiteley knew what hours Satan kept. And he knew the secret password to get into hell, a place he liked and trusted. As his friend the painter Peter Kingston told me, 'There's actually no pity in the Whiteley story, because Brett did exactly what he liked. He lived a thousand lives in those fifty years.'

I've put in a request for his rocket to stand still so I can take a proper look at him.

1

Upon a blazing, blustery November afternoon I enter the gates of Sydney to look for the truth about Whiteley's life and zippy times and hear all his friends reminisce. As I walk down towards the Harbour, a restorative sea breeze collars me, embraces me, turns me on. In one big gust, I suddenly realise just how much I miss Sydney. You'd be made of stone not to give in to its sensuousness and nonchalance. By Christ, Sydney warms up your cold soul.

Here, you seem to see more in some uncluttered way; no grit gets in the eye of the beholder. Sydney is gauchely opulent, loquacious as a rotten mango. Out there on the Harbour, rich drongos are having an arrogant sail, and alcoholic architects are having their way with bored boys from Balmain who didn't quite make it into film.

And there, on one of the winding streets that lead down towards Circular Quay, shuffling in the dust of the old footpath outside a school, performing a gently eccentric dance and a skip-action, is an earlier incarnation of

sensuous sydney

the artist himself. The same carrot-red tangly hair, blondy–red eyelashes quietly blinking, the impish and defiant grin, all his old alchemy—this is the shade of him, all right: his own secret whirling dervish come alive again. He looks like this bemused ghost. Just a bright spark out dancing away the boredom, he is shuffling through sun perforations in heaps of golden scattered leaves, carrying his schoolbooks on a strap—surely this is the late nineteenth century, not the twenty-first?

And, thus introduced to Whiteley's living spirit without the fuss of introduction, I walk on towards Circular Quay. I shield my eyes from the stunning sun on a little blue boat that bobs across the Harbour, past Luna Park to Lavender Bay. I get off and walk straight up a perpendicular stone staircase carved by convicts long ago. Up, up I go to meet Whiteley's divorced widow, Wendy. She heard me on Margaret Throsby's program on ABC FM and says she feels, therefore, as though she's always known me.

I am greeted by long, twisty Whiteley giraffe sculptures looming over the chimney pots. They don't look half bad with their painted spots and patina. And so I am giraffed up to an incredible white tower surrounded by minty-, honey- and musty-scented bushes and ancient trees all waving together, twinkling-leaved, sweeping me into somewhere friendly but slightly sinister. A solid sighing fortress of solitude with him not there any more. But he is there, certainly, as the feeling of him is everywhere. Perhaps he'll spring up at the grave and laugh at me …

Wendy is here, though, as though nothing has ever changed. She's just got out of the bath, a big white fluffy towel around her, and a friendly smile.

I remember all the sensuous 'Wendy in the Bath' paintings—elongated limbs, curvaceous plumbing (both hers and the bathtub's), the epitome of opaque and glazed exoticism. The genius of this series is the spontaneous and high-speed master control of the liquid brushstrokes that play havoc with each loony but master touch. They are very daring and breathtaking works of art, with multiple tipples of envy worked in. Brett called Wendy his Muse. That must have put a lot of pressure on her. A relaxed Muse she was, although she tells me she got tired of sitting in the cold water like a stunned mullet.

Music is playing—Bach piano—as she deftly composes a salad and we converse about this and that. In many ways she seems to defy heroin, alcohol and excess. In the gyrating brash loony 60s, Wendy and Brett were pop's Adam and Eve. Both

spoke remarkably, smoked voraciously, drank unquenchably and fought publicly and spectacularly. (I think of all their fights as she passes the basil and the chilled white.) Now she's off alcohol as well as heroin. Off everything except the fun of life. Her calendar is always busy.

Sydney Harbour is a perfect background for her musings. You can't help but think you're actually in one of Brett's paintings as she takes you into the past.

'When was our first date? I was about fifteen, and I was going to go out with a friend of Brett's, but then Brett himself turned up and took me to a place called the Sketch Club. He said my drawings were better than his. That buttered me up. No wonder I liked him! These were the days of thin Drum cigarettes and incessant bongos. Calypso nightclub background and 24-hour everything-all-at-once, including orgasms. You know what I mean. I hope you know what I mean!'

She laughs uproariously, recalling Sydney rock oysters, plenty of drink, contented times, cool jazz, endorphins of every triumphant chemical boost available.

How has she kept herself together all this time? She looks pretty ravaged but she has incredible panache and the spring and strut of youthful defiance.

Brett's pictures are everywhere; wall-to-wall Whiteley, wonderful and ridiculous. He was uneven; you see that at a glance. She runs a museum of his work these days. But it's Whiteley's affairs, not his paintings, that are on Wendy's mind just now.

'There were always women dangling off him, and he'd stay over with them often, then say next day it was nothing. I thought of those young idolisers out there, obsessed with him. But if they got annoying, ringing or whatever, he'd surprise me by saying "You deal with it." What if they wanted to commit suicide?"

'Like all men born in 1939, he was a fucking misogynist and a hypocrite. A real Thirty-niner! He thought he was The Man, you know? But he wouldn't permit me to have a car in the Swinging Sixties! I had a lovely Citroen once, a beautiful little car. If you got a blow-out, these mechanical jacks shot out and jacked you up, even on wet grass, so you could change the tyre. I loved that car. And fucking Brett drove it over a cliff!'

She passes me a savagely sliced sliver of melon to go with my prosciutto and takes one or two sips of bubbly spring water.

'I'm in AA,' she says, 'and Narcotics Anonymous—never felt better in my life.'

'Did Brett cook?' I ask.

'No.' She laughs. 'He'd do a decent barbecue. But no housework. He was too privileged to do that. He'd offer to pay a guy to rake up leaves. He'd often throw money on our kitchen table and scream, "Look how much I make! I can do a twenty-minute drawing and pay two cunts to rake the fucking leaves." But if I took him up on the offer, he'd hit the roof.'

Her gardener comes in and sits down and glares at me as if I'm a dero.

'He is my invited guest,' Wendy yells protectively, and inwardly I politely thank her.

Wendy's chatting again now—pretty speedy. 'Brett had so much energy we didn't know how to burn it off. We used to run into the high grass down below this place, and we'd slash grass for hours with scythes.

'He was terribly messy when he painted, with squeezed-up mountains of crumpled, stomped-on oil-paint tubes. Mountains, underneath which maybe there was a power bill he'd overlooked and couldn't find. Because he was born in 1939 he thought like 1939—you know what I mean?

'But I really miss his friendship. We were best friends and he was so much fun. That's what people don't understand about him.

'He missed the birth of our only daughter, you know—Arkie. He was quite angry he missed it. She was very tiny. Brett was doing all the birth classes and the breathing classes and the yoga classes, and he came in a lot to see me in hospital. But then he went out to dinner with his mother the evening I went into labour. I was calling out his name, "Brett, Brett, where are you, Brett? The baby's coming, you *bastard*!" The reason he wasn't there was that his mother was stuffing him with pud! One dish he loved was bread-and-butter pudding, because it was dished up at the boarding school he went to—sultanas in it and all sorts of other glug. Revoltingly nostalgic!'

I'm looking now at Whiteley's so-called anti-heroin etchings, but there's something wrong with them. Everything is

in place—the syringe is in place, the artery is in place, the drawing is in place. So what's missing? Perhaps the pity is missing. And meaning. What do they mean? He claimed they were meant as warnings, but when I look at them now I think they're a tribute to smack. He wants his addiction both ways. You should have, you shouldn't. In the end, they're just decorative.

But look at this picture. It's Whiteley's interpretation of the Buddha—a lovely wash drawing of a monk gesturing, executed with a delicate sweep from the Orient. He's brilliant at raiding mysticism and he can honour the forms of the ancient Sumi ink paintings on old rice paper. He's even signed it with a seal. But the seal looks like a BMW logo. I walk over to the work. It is both original and copied. When you have such a beautiful eye, does it matter if you copy? Better a good copy than a bad original, or so they say.

Meditation was more-ish in the late 1960s. People dabbled in anything that was avant-garde, and Brett Whiteley had to be at the forefront of every single fad. But how can you meditate if you're stoned on heroin? How can you know the truth if your body and mind are both drugged? Was he kidding himself? He was a remarkable rocketing man, and I suppose he thought he needed something to slow him down.

Masterstrokes

With *Untitled Warm Painting* I, achieved in 1962 before his interest in nudes or yachts, there is a dazzling discipline conveying ovals and linear wonders that seems married to infectious

childishness and wilfulness, painted the way a happy boy would. Using tempera and collage, this and *Untitled Gouache* (1961) are heroic brave sweeps of joyous colour bunged onto a surface that celebrated complete away-ness from books and art schools. He's so free back then.

Similarly, in *Woman, Basin and Mirror* (1963), there is a wild and almost hysterical creaminess of texture that seems to be slapdash but is actually masterful as well as precise in the extreme. In a very strong sense it is true that what once was novel is also heroic. Painting aficionados had never in their lives seen a picture like *Woman, Basin and Mirror* because the boldness and control and spontaneity and inventiveness had not been in our world before.

My time with Wendy is up far too quickly. We arrange to talk again, then say our farewells. I catch the rackety train over the bridge to St Leonards, near the Channel 9 television studios in Willoughby, where I am expected by the painter and Archibald Prize winner Keith Looby.

Oh, to copy the uncopiable

In 1968 the world was in riot, with gratuitous violence committed against students in Paris, America shooting its students not only in the foot but in the brain ... So travel, blow dope, get hooked and go to the Chelsea Hotel to save America by painting pictures they didn't want.

The whirlwind has to sit down. Luckily he always had an

indestructible solitariness and teflon tongue with which to speak, or decline to speak, and monastically could steal away far into his small tight hide and deal only with red or grey or the other brethren of the secret palette. As he demonstrated nearly all his life, he could always get out of the line of fire and draw to escape either mockery or criticism. Scholarly he scrutinised his dial in mirrors and you see in the mid-1950s charcoals of his face: a great draughtsman equally determined not just to draw well but to draw best. At fifteen or so he was possibly as good as you get at portraiture.

Some of the early satiric and social caricaturing drawings of his later teenage years owe thanks to William Dobell, with subsidiary thanks to whole armies of people. *The Soup Kitchen* (1958) is a pseudo vindication and false tribute to Van Gogh because, despite any attempt to like the poor, Whiteley doesn't exactly hate them but is indifferent to hunger and loneliness of the spirit, so that the characters in this dud appear fatuous and diluted rather than socially exhausted, even near death. Much lauded but to me a joke, it features deros in the foreground who are the spit of Clem his Dad and Beryl his Mum. What's missing in this work is pity: there never was any in him—and none at all for him. The homeless alcoholics have neither form nor invention and the only beauty is the rendering of the foreground china coffee cup. He's no Noel Counihan—the super social realist and capturer of poverty and paucity of hope through his works faithfully showing uprootedness as well as just plain rootedness. Whiteley, being so vain, has artistic

sympathy only for beautiful objects like himself.

The Road to Berry by Lloyd Rees is seen by mostly Sydney misunderstanders of sex to be sensual landscape and Whiteley does much by way of homage to the ancient Rees. He becomes all the artists he visits and he revisits their studio secrets to raid scraping-away and putting back of pigment and dissolving surfaces. At a soup kitchen he has too many Modiglianis in his noggin to really see the poor old bastards on the turps; consequently the painting is by committee, not solo.

To my way of thinking he stopped being clever at the easel as far back as the very early 1970s when he raided Van Gogh. Vincent remains enigmatic because he was an anachronism even when he was around. He was chuckled at by Parisian painters such as Monet and Manet because he couldn't draw anatomically right. His figures resembled plasticine models all squished around. The hands were pudgy and nothing like real drawn hands, but the thing about Vincent's drawings and paintings was their astonishing sincerity and faithfulness to his Christian adoration of honest people, such as the Postie, whom he drew and paid real homage to.

Francis Bacon wrote to Whiteley regretting having paid homage to Vincent Van Gogh because Van Gogh is uncopiable. There is no point loving him by painting like him, said Bacon to Whiteley, but Whiteley immediately did his own homage to Van Gogh that is completely facetious.

Ivan Durrant told me that years ago he was part of a group show at Georges Mora's Tolarno Gallery in Fitzroy Street,

St Kilda. He was sitting next to Brett in the middle of the main exhibition space. Brett was speaking quietly and he looked bored. Then Ivan realised Brett was hanging out.

'Have you got any smack on you, man?' Whiteley asked him.

Durrant replied, 'I don't use it.'

Whiteley ran outside across to the tram barrier and bought a deal off a kid who'd just got off a tram. Whiteley put it straight into his arm without knowing whether it was any good or not or even fatal.

'He must have had a pretty low regard for his own life to do something like that, I reckon. After he OD'd at that motel I did a silkscreen picture of him, and then I made a stencil with "OD" on it and stamped a great big fucking "OD" over him and sent it to the Whiteley lot. He's supposed to be the loving father and the great protector, but to me he betrayed all the natural principles of loving fathers. The clan aren't rapt in me after doing that.'

Through all his days of drawing like a monk, months of feeling fulfilled through the healing force of drawing, he was as honest as he could be. The clean work is childish but sophisticated. You can't really call it copying the ancient Chinese masters, because he was as good as them. He was as good as anyone when he was being serious and working without kidding himself. He was a beautiful artist when he set mockery aside.

2

Let's leave Sydney for a second, forget the way it all ended in a motel room in Thirroul, and go back in time to 1970 and Anderson's old furniture store in Collingwood, Melbourne. I'm walking up freezing-cold Smith Street with Stuart Purves, the man who organised the big group show where it was all happening, man. As we duck into a posh restaurant doorway, Stuart wheels around and: 'Do you think he killed himself?' he asks as the door thumps shut. It sort of throws me, the way he says it. I can't find a reply. I wasn't expecting that remark, I have to say.

We sit down at a mile of white linen stuffed full of steak-knives made of globular silver and cannon-sized pepper-mills and copies of Waterford crystal champagne flutes. The waiter pours our drinks off-handedly, as though he's only a third there. Stuart shoots me a packet of Dunhill full-strength cigarettes, and we speak of that big show.

As we peruse the menu, I think about a private photograph of Brett that Stuart showed me back at his establishment, Australian Galleries. It depicted

it's all happening, man

Brett outside a fishing tackle shop with the words *eighteen inches* crudely written on a sill. Whiteley has his cock out to upstage those silly fish, and is grinning as if to say 'Up you for the rent!' Funny, not funny ... it doesn't matter much, because it shows him in miniature, so to speak.

In 1970 Whiteley organised a massive group show in Smith Street. His works were so enormous that he required much larger walls than those at Australian Galleries, and he somehow stumbled on Anderson's, a monolithic furniture place in Collingwood.

'Brett was amazing at finding things no one else would have the foggiest clue about,' Stuart enthuses. 'My gallery was too tiny for his colossal works, so he seemed to deliberately bump into a mysterious Lithuanian Jew. You know what they say about Lithuanian Jews, don't you—if you hurl them through a revolving door they get through it before the door shuts.'

I haven't heard that one before.

'So we bunged on this huge show—August it was. The poster depicted Brett's drawings. It was all typeset in lowercase like the popular poems of e. e. cummings. You know, Brett was way ahead of everything and everyone. Always one step ahead.

'Martin Sharp had one floor and Mike Johnson had a floor, but Brett needed two. The poster copy said things like "side glances" and "films by brett" and "musings by brett". I can't quite recall whether there was any mention of other artists on it. Everybody who used to be anybody in society flocked to it.'

Out there in shivering Smith Street, other dealers are hanging around outside the supermarket. The restaurant is like an oasis in a sea of syringes and shattered plonk bottles.

'Rather ironically, there was an unexpected power strike on the day of the opening, so you couldn't see a fucking thing. I had a word with someone at the council, and we got the power on all right. Then I scurried around town with Brett, going to all the art stores—Deans, Norman Brothers, you know—buying up every conceivable bit of black cardboard and black paper we could lay our hands on. We stuck them to the windows so that we looked like we were in darkness, but inside it was as if the sun was intending to explode.'

Stuart orders our supper. Bangers and mash, chunky chips and champers. The snags look preposterous.

'I went into that exhibition a boy and came out a man, thanks to Brett. Until then, my mother or father used to present our exhibitions, so this big Whiteley thing was terribly important to me.

24

'Brett taught me professionalism. He always presented beautifully—he thought and spoke incredibly beautifully. I was just a kid at that show. He inspired me to do my absolute best, and I honestly thank him for the lesson in stylishness. He was the epitome of the word *debonair*—he was so flash! He just came bounding down those staircases grinning and purring, saying things no one could say and being a man no one could remotely be. He was like a beacon, like a fiery comet during a miserable power strike. Everything sold in a millisecond, as soon as it opened. You had to be there.'

I *was* there. I had gone there with my friend John Paice, once a fellow press artist at an art agency called Moulton Advertising in Little Collins Street, where I was executing black-and-white finished artwork for the old *Herald* newspaper. I had to make saucepans into erotic items for people reading the paper during a half-hour of claustrophobic tedium in the tram on the way home.

John Paice had the unique distinction of executing the original artwork for Cadbury's Nut Milk chocolate wrappers, and he did the nuts without having to look at real ones; he sat next to me at work, so I know this first-hand. He made the nuts up. What a feat. He drove a fabulous big black Bentley and we hammered up pitch-black Smith Street in it, heading for the show.

'Fuck me dead,' John confessed when he saw the exhibition. It was the work of a master showman—or should that be shaman? 'What in the world am I looking at?' I asked myself,

here on the second floor of unreality in 1970 in Smith Street, Collingwood.

Hundreds of erotic people, all smelling like sandalwood mixed with money. Unbelievably groomed bouffant hairdos that look like fairy floss. Beautiful black women in white off-the-shoulder creations by Geoff of Paris. Six-inch-high silver stilettos, as if they're walking on stilts, and men with breasts like horizontal ice-cream cones.

A crush of art collectors, desperate to be seen snapping up a Whiteley, and the man himself, bunging on the charm. Everybody an overseas nobody. Everybody Elvis Whitlam. The noise is irresistible, mind-blowing. Nothing is as it appears, because modern art has gone crazy and normal life and normal thought are finished. 'Fancy a zebra kebab or a zodiac pretzel?' Look at this Whiteley, will you? It sold before they put it up. He must be richer than Croesus.

Tonight's edition of the *Herald* had a story about Wendy. She told the interviewer that she didn't feel hung up about running a shop that sold furs, because after six months the animals' souls leave their bodies anyway. You can't take a comment like that seriously, but it is a great thing to say. Perhaps it's right. Tonight she is wearing bellbottoms and bust. She is absolutely stunning. She is Jacqueline Kennedy. So sure of her beauty. His.

Everybody is smoking dope, and I don't even smoke ordinary cigarettes or drink alcohol. I'm just a 21-year-old nobody.

Now, how has Whiteley done this picture? It seems to be two lovers screwed buttock into buttock. Their limbs have

been made of sawn wood, sandpapered white gum-tree branches glued, everything's been *assemblaged* to a real mattress—or is it painted? Or how about the way he has suggested the franticness and pawing at each other by drawing and scraping away all kinds of glued ripe textures? The mood is of rippled ribaldry, nippled urgency, and the sheer imagination of the glued branches that become the Edwardian Big Brass Bed.

Whiteley is laughing next to me. He is chatting amiably with Bill Cosby. One of them is saying 'Let us examine our idiosyncraticness', and the other is eating a turtle cheese triangle that wriggles; apparently they're nicer alive.

Now there's this other painting, and Whiteley is explaining it to me with a little patience. I don't know what he's talking about. Oh, well, give him a chance. He speaks fluent North Shore—a bit of a turn-off—and I strive to overcome my working-class prejudices. Boy, he knows how to talk!

'How I went about making the homage to the miracle of this particular crest of a wave was to truly and very deeply honour the itness of its wondrousness and to seek alchemical truth. What I felt I had to do was wander inside the regarding wave, free up the disingenuousness of its ultramarine selfishness, because that's the only way to be in the beginning or the end.'

Is that right?

'That's why I have re-entered the consciousness of this old gate that I discovered on a house, adhered it to this already existence of a wicked bit of old scuffed picket fence and collaged the whole thing to a primordial image of sexual

foundness indicated by, but not dictated to, the cum arriving on her panties, do you follow?'

No.

He hitches his shrunken blue denims with his hoary red freckled wrists and tightens his belt with an enormous silver buckle on it and goes and presents himself to a real-estate guy. I gaze up at the overhead projectors beaming onto silver foil screens. The imagery keeps changing from occult mind-streams to Super-8 footage of Cambodian atrocity horrors, because Australia is still fighting innocent napalmed villagers.

It is an ocean he is painting: an ocean with cock and balls, an ocean made of political collage put together with drugs and drink and superglue and ping-pong-ball-surfing homo-erotic transmutant photo-realism on steroids. You can smell tea-tree in it as well as dirty fence.

John Paice says that Whiteley had a word with him about dealing directly with indirectness; he also says Whiteley is working drunk and enjoying it more. We drive, verging on drunk, back to Fitzroy, both of us trying to hang on to the excitement. But we're running out of puff. John is still raving about Whiteley, with the freezing wind flying through his fur coat. When we get to Paice's place, everything seems flat and real. We have a beer, but it's flat too. The party's over.

VIVIAN ENDINE WAS at that exhibition. I've known him on and off for thirty years at least, and my main recollection of him is of his generous, helpless, catchy, full-throated laughter. He's got

polio, but it doesn't get him down—nothing seems to. Today I've popped over to his successful jewellery shop—crammed with delicate Balinese bangles and Nepalese necklaces—in pompous, moth-eaten Prahran to see what he can remember.

Hearty as ever, he swings on elbow-crutches out into the street. We both dodge violent trucks delivering pure snow-water; their drivers are always furious for some reason. I notice that an over-zealous parking inspector has pinned an infringement notice on the window of another parking officer's car. It's not just painters who persecute each other, it seems.

The cafe is raucous and couscous; everyone here seems to be a film editor. Vivian orders us some toasted cheese-and-tomato sandwiches as well as a couple of fresh orange juices and cappuccinos, then launches backwards in time without a qualm.

'Oh, yes, of course I remember going to that famous group show. I went along with my mates Phil Motherwell and Lindzee Smith, who both followed the avant-garde scene. It was the most unbelievable event I'd been to in my entire life, and that's the fact of it.

'You went up these sort of melancholic stairs—maybe art is melancholic anyway—and it was three or four levels of art at the cutting edge. You heard this remarkably inviting music, and there was strobe lighting—that was the trend then—with hordes of people. So many people walking up those stairs of this barn of a place, transformed into an ark, it seemed, full of feversome lovers grappling with their identities. Silver paper in great massive rolls pinned up to the ceilings with pink and

green reflections and recordings of fountain water cascading and light purple men gazing at fluorescent invitation cards and the press looking like Clark Kent.

'People smoking illegal substances reviewing the paintings. Men with silver boots on, and critics and architects with make-up, and all this mystical patchouli fragrance, and kids smoking Gitane cigarettes that stung their eyes. All this astonishing confidence in the room, with Brett Whiteley like a lord.

'I saw her, you know—Wendy—serving succulent unheard-of curry things—unheard-of in those days, that is. The whole effect was all-conquering and totally awesome. People just got knocked right out, sort of weakened—you could go so far as to say delirious—and started writing out cheques on the spot. I think they all sold, Whiteley's works on paper or canvas or tractors or corrugated iron.

'You gawked at pictures you had no way of getting into, like the long-armed desperate lovers screaming out for attention, and things rather like nightmares or chattering chimps with speech bubbles and pop and comic-book art and real prosthetic wood thighs stuck in painted bums and plaster rivers and vivid deep blues and lemon colours and apple pips stuck onto actual pubic hair. What did it all mean? But you just took it in and it got to you and turned you right on.

'I was at that amazing thing for three whole nights. I went to sleep upstairs, and all kinds of people kept on getting up and going out to get more wine and cigarettes or score some grass.'

The waiter asks us if we feel like a wine or a beer, but

it seems too early or too late at around midday.

'I think the world was a very innocent place then, when I remember the beautiful erotic work at that exhibition and the swirling lights and brilliantly dressed people who looked stunning even at seven in the morning after talking and laughing all night—all their senses lifted up and conversation lifted up … Well, what's wrong with a bit of fun, a bit of showing off?

'After three days I went back to work, and I never felt better in my life.' He's exuberantly nostalgic.

'In those days you looked for something like outrageousness and excess and extravagance and brightness and interesting new film-making and designs that were breathtaking,' he reminisces. 'In those days everyone was a friend to the other, even if they were stoned. When Whiteley kept on jetting over to Bali for the world's best hashish—Jesus, think of just how innocent that used to be.'

Whiteley at this stage, in the early 1970s, is painting like a man running in front of heavy traffic in order to see what will occur. What occurs isn't occult or otherworldly but chaos. It isn't even paranoia because the horror doesn't translate from an obsession with being at the cutting-edge and crap. You get the impression, after he has revisited so many kinds of avant-gardeners, that he needs a decent prune himself because his natives are out of sympathy with his imports. It's a mad overgrown garden of copies. Is he interested in any new style he takes in or is it more crucial to upstage them? Everything in his is combative. It's as if he's trying to beat himself as well as all other artists.

3

'My father Bruce Galloway was actually the principal of Scots School in Bathurst and I went to school with Brett Whiteley,' says David Galloway as he sits under the apricot tree with me, apparently completely relaxed although he seems to sigh a fair bit, this 66-year-old cultivated gentleman.

'My father built that college up from scratch. It was a haven in a way, during the war. If Sydney got bombed kids'd have somewhere to go. There were about six or seven very young children in each class, and in one of these classes existed Brett Whiteley. Brett, at that stage, was a very little boy with a shock of white curly hair and a calliper on his left leg; the kids who used to wear them had been to the Spastic Centre. This fact set him apart.

'A lot of kids sent to boarding school were of a very young age. They were sent from the centre of Sydney for the fresh country air. To get rid of asthma was one reason. Another reason was that the mother and father might have split up. Brett was only six and so little when I think about it. I was a few

the rudiments of drawing

classes ahead of him and a few years older, but I often wondered what became of him. He was an attractive little boy—I very nearly said pretty.'

He cups his enormous hands and stares at me from a lofty but not elite height, a friendly great height. A lot of his life he's worked as a vet. I met him through friends of mine at the Lost Dogs' Home in North Melbourne.

'He wore that calliper all the time. I have a visual memory of him playing cricket with it on and running furiously between the wickets, running with the bat. The white snowy hair and calliper stood out.

'I also have a vivid memory of Brett playing marbles in the dirt under the myall trees of our old school ground. Yes, that's right, we used to play marbles in these little hollows in the dirt there. You'd roll the marbles down the grooves. How did he learn to draw? Well that's a good question, and I think that drawing was absolutely necessary for a tiny boy to be good at, to beat the others at something. I think it explains his stance. My mother took on caring for the

little ones at the school and she taught him spelling and the rudiments of drawing.'

He smiles and wiggles his fingers in the air to indicate drawing. He's this giant child all right.

'My mother gave those children formal lessons in art. And the writing those children did was a kind of rehearsal for real writing. Pencils and paper I seem to remember. There must have been Leviathan Crayons. Do you remember those cheap crayons? They were everywhere in the war years. No matter how hard you tried to draw with them they simply wouldn't stick to the paper.

'I seem to recall a big house. It was built by the family who built Arnotts. It was a big house surrounded by poplars. The little children's classes were at the end of this house. I sort of see a wall of drawings, that's where the *best* drawings went, that's where they were pinned up.'

I pass him some photographs of Whiteley's old school and he holds them close up to his spectacles. In the pictures Whiteley looks so tiny and so disconsolate, a *really* little boy indeed. He looks, to all intents and purposes, completely cut off and abandoned.

'Oh this is *tragic*. Look how much bigger the other boys are. And in this picture you've given me they appear to be laughing at him and tormenting him. It's hypothetical but there are two things I really should say. He's so small and vulnerable and so young to be in this great big boarding school and on his own. I see now how he grew up. I mean he was there for ten

years—from the age of six till sixteen. He's gone from this little boy to becoming a young man there.

'He's aged ten in the football team there. That's father in that photograph there. They've still got the same desks and the same clothes!'

The giant body rocks and laughs. He laughs with his legs, his enormous legs, and especially with his back. It's a catchy convulsion.

'There was an open weekend every term and therefore the students went home on their holidays so the boarding school was cleared out on the holidays. Speech Day was when parents did come. Whether or not his parents visited him, I couldn't say; perhaps his parents were separating or something.

'Let me talk about boxing. Boys got in the ring and boxed their hearts out and I learnt how to hide my fear in boxing. Brett Whiteley's progression was fantastic when you look at these pictures here. Boy did he learn to dig in and fight with all his might!

'I've always been a vet,' he sighs, folding up the photographs of Brett Whiteley, lightly. He's got the lightest touch with everything, particularly memory. He brushes some tears away with a handkerchief.

David Galloway's sister, Helen McGeorge, is one year his senior. 'Very early I met Brett Whiteley because he was the youngest in the class and he stood out therefore,' she tells me. 'I was the headmaster's daughter and our quarters were on the first floor of this place called Karralee. My old room was a

typical room in those days—it possessed a beautiful door of mahogany—and I was eleven. I'd just finished primary school.

I was at the new school for four and a half years, and I remember that Brett was a very little boy. My bedroom was right next door to the littlies' dormitory. Their dormitory had really dark woodwork, with an arched window at the top. They had a lovely view of the river and you could see all of Bathurst, just about, from there. How many boys? I should think about eight.'

She's very pale and frail but full of scrutiny.

'Our matron at the time, Beryl Phenister, was a trained nurse but she was also the daughter of the jail manager. She wore a uniform. They had to be good at First Aid—good at cut legs, good at coughs and colds and skinned knees—a lot of skinned knees were presented because the boys, only five years old, some of them, wanted attention. I get terribly upset about this. My Mum used to comfort them—you know, joke and chat to them as they lay in their beds.

'They didn't have much in the way of books but my father built up that library. He bought some pigs one day from a local orchardist. The pigs came to live in a pen. David and I used to try and drive these piglets towards their pen but they declined to do what we said. On one famous occasion, I remember, one of the pigs died. We all were to write a letter, I suppose as an English exercise or something of that nature, and all these kids wrote how sad it was that the pig died, so we ate it. My upset father declared that the post mortem let it be

known that the poor pig choked to death. It was a sad time.'

'Marg, my Mum, had a very creative spirit. Most littlies, to survive, had to be defiant—to protect themselves. The littlies used to play around the building. They loved to play on the drive that came right up to the side of the house. My best memory of Brett had to do with the littlies. At the age of four and a half, they had to make their beds and turn the sheets down: they had to take off the bottom sheet and put the top on the bottom.

'At night a prefect put their light on and the little children sipped tea. I can see all those little cups and hear all that little sipping. This was at six o'clock sharp. We're talking about 1945, when the war was over.'

She keeps fidgeting, with her brother looking down. She rests her fingers on her forehead and tells me: 'I can see Brett right now, right in front of me, I can see his face from those school days. That little face is so serious and quiet, it's like a glare. He must have hated it out there, really hated it. I used to play with him and all his little mates. Marbles, we all played a lot. I remember Brett with boxing gloves on as a little boy— you know, the sparring gloves … the weight of them bowed his arms forward. A man came to teach the children boxing and he always picked the skinny and the scrawny first, for some reason.'

She's really very agitated, but she's smiling and that belies her nervousness and sensitivity.

'He's right in front of me as we speak, very white. He

seemed to look sunburnt some of the time. Brett's got a worried look, a constant worried look. He had worry lines in his face all the time, as if he was looking for answers. I've often wondered if his spirit and defiance started due to a terrible start. I've thought about him often.'

BRETT WHITELEY ONCE CLAIMED that, when he was about four years old, he had relived his own birth in a dream. He was caught in a narrow pipe—the womb—struggling and sweating to get out. And written on the walls of the womb he could see two words: *security* and *rebellion*. In the dream, he hauled himself out of the pipe and sat for a while, 'trying to work out which one I'd go towards'.

In real life, there wasn't much doubt about which way young Brett was going. His parents had everything—wealth, importance and a hydraulic social life—but this didn't leave them much time for Brett and his elder sister, Frannie. The kids soon learnt not to try to gatecrash their parents' parties. Instead, they'd climb out the upstairs window, scramble down a tree and disappear into the shadows.

A fairly bright boy with no interest in school, young Brett had a lot of time to fill. He was crash-hot at improvising, making fun out of thin air. It seems he used to torment sleepy lizards by extracting their insides with miniature pliers. 'Now you're stuffed!' he'd snarl. Why was he so fond of tearing things apart? Typical kid, on the one hand; the makings of the man, on the other. Blowing up the recognisable at all costs and then

reassembling existence itself into a new picture. Resurrections while you wait.

But he also liked to put things together. Look at his later obsession with constructing nests—all his life he collected birds' eggs and rebuilt their nests in his own way, making art of them. He was creative and destructive in equal measure. Maybe he couldn't tell the difference.

Phil Maloney, a boat builder in Sydney's suburb of Lindfield and the brother of musician Paul whom I'm to meet later in my pilgrimage, was a member of Brett's childhood gang and remembers him well. 'He was fairly frank and deep and assertive, full of poise and a natural confidence. He had a studio thing under the house—a sort of den, you know, where we'd go to hang around after school. It was somewhere to congregate.

'He was a little bit swish and mischievous. The baker would leave hot, fresh-baked bread in the little cupboard on the front porches of people's residences in the old days, just after World War II. Brett would come along and just take it if he felt like it. He'd scoop the hot, doughy bread innards out of it and eat it. This lady—a nice, friendly, probably hardworking mother—she left a note for Brett saying "I wish you wouldn't eat my fresh bread like that", and she pinned the note to the porch cupboard for him to read. Brett wrote her a nice note back, saying "But Mrs Smith, it's such lovely bread."

'I can remember coming home from the pictures, in the days when people used to leave their empty milk bottles out

to be replaced by fresh milk in the morning, and Brett came along and chucked a milk bottle at a street light.

'He'd get over people's back fences and swim in their pools. Isn't that provocative? Floating around in someone else's pool? Or lying on the bottom looking up at them?'

Cricket, 1946–64

The Cricket Match, executed in 1946 with pencil and watercolour when the boy Brett had achieved seven-not-out in years, shows a skill at sarcasm and sport and mockery with respect to the elegantly comic wicket keeper and the bravado attitude of both batsman and bowler that are sadly missing in the late crook work not fit to look at. The brilliant revisitation of this picture, still called The Cricket Match, in 1964, utilises all that was satiric in the infant drawing but adds phallic eroticism by virtue of the outlandish position of the cricket bat. You can never take cricket seriously again after looking at it. Here he is at the top of his form and has mastery over the medium, of both oil painting and social commentary. The rendering echoes the Doctor John Christie masterpieces, but here the idea is also to amuse in a kind of gentle vaudeville way.

David Galloway put me in touch with Petra Santry whose father and mother used to run an art school near Brett's home in the Sydney suburbs. It was a very bohemian household, as is hers today in the Melbourne suburb of St Kilda. Her house is full of paintings and drawings and prints and, on every

table, overflowing bowls of tropical fruit. She looks in her mid-sixties and speaks with a sort of eclectic fascination for everything. She changes the topic every second, which is how modern history should be spoken. Her voice is light, with a true musicality that's good on the ear.

'My mother, Marie Forli, was a brilliant artist but she was rather tormented as a soul. Dad was head of life drawing at East Sydney Tech. He exhibited successfully each year and he was sort of influenced by everyone but, as you can see by his work here, he was a traditionalist. We lived at Northwood, near where Brett lived, so I knew him when he was a young teenager whenever he wasn't at that country school, such as during his holidays.

'When I left school I went and worked in art studios in Sydney, doing commercial drawings and so on—commercial artwork for J. Walter Thompson, one of the biggest advertising agencies around in those days. My dad was a commercial artist who did finished artwork for lots of popular magazines, but he was a professional painter as well.

'I was always going to and from Circular Quay, always rushing around everywhere, from pillar to post. I was a real eager beaver. I still am.'

She laughs and offers me a luscious orange, which I decide to keep for later.

'I worked as a fashion artist for an advertising agency called Farmer's and my boss was Leo Schofield. He was the head of Farmer's advertising. I came straight from high school with

a folio that my father had helped me put together. I can see that folio now, stuffed full of hope. I've still got my folio, in fact. I've tried to keep everything, including the best of my mother's paintings.

'Brett used to call her "Mummy". He was a very young teenager at this stage, and he was always coming over to draw from the model and to talk really deeply with Marie. He was at a loose end because his mother and father were cupboard drinkers. (Lots of wealthy mums drinking at home to overcome their boredom in the dreary suburbs where everything was so dead.) Marie and Brett were incredibly close, I remember.

'My father thought he was Augustus John and ran off with my mother's sister and went to live with her in her flat, so I grew up in a sort of a tormented and wrecked home, if you see what I mean. There was just so much pretence going on, now I think about it.'

She sips from a glass of icy water, and immediately offers me some.

'Dad did all the *Women's Weekly* covers, you know, the art-work. Big breasts and gloves and stuff: line and wash. He worked at home, or at that flat with Mum's sister. From the age of eleven, until I was engaged, I was sworn to secrecy about the fact that Dad did not live at home. Mum made me swear it.

'I don't know really whether Dad was an artist, but Mum was one. She thought as one, and acted as one, and at her best was brilliant. She influenced Brett Whiteley in respect of her philosophy that you could actually paint movement and

draw movement. She influenced him much more than Lloyd Rees is supposed to have. I'm not so sure that Lloyd Rees influenced him much at all. Whiteley said he did, but look at Mum's drawing over there on the wall.'

I gaze up at this wonderful picture executed swiftly in swirled chalk and black charcoal. It's hard to tell at first what it's supposed to be, but it's just so alive with arms and eyes, suggested and emphasised unrealistically, that it put me in mind immediately of Whiteley's famous Ravi Shankar drawings of vibrating sitars and whirling wrists and floating fingers everywhere. The antithesis of still life: unreasonable, hyperactive life at all costs, with thought vibrations coming out of the twanging happening-ness of it all. I reckon it's Whiteley's best picture.

She leans her fingertips on her chin and her eyes are suddenly very big, like apertures opening on a camera somehow.

'You know that famous picture of the poodle moving … I think it was done by an Italian in the early part of the twentieth century. Uncannily it depicts a sort of frantic movement of that groomed poodle struggling on a little leash. When you up close to it, it's just a mass of lines everywhere. It really looks like it's moving. Well that's what Marie was interested in, too. It influenced Brett as a young teenager; he just collected so much information, was just so keen to learn.

'One night I saw my mother weeping. I'm sure my father had hurt her feelings. She was really crushed, all sort of bent over. And Brett was hugging her and saying, "What's the matter, Mummy? Have they been getting at you?"'

She goes blank, like a record stopping abruptly.

'He was really very sweet and sincere, with this mad curly hair. Mum felt very protective towards him because he used to come on the bus with us from Lane Cove to Wynyard. I'd often take him home on the bus to art exhibitions, so we'd talk along the way about all sorts of things. I used to see Wendy on the bus, she was unbelievably beautiful as a teenager. She was so gorgeous and warm. My mother was so disapproving of Wendy.'

Drawing from the heart

When the famous couple came back to Australia in 1964 Whiteley's new beach series was vanity set in sand: him drawing himself at Whale Beach with clipboard and self love. Insular, unsatiric, his *Bather on the Sand* cannot be taken for real. He's hurting his name.

But in *Shankar*, a charcoal of 1966, he moves up several gears to achieve a right braveness and crispness that he owes to his real Muse—Marie Santry—who taught him as a teenager to capture movement and music that could also be drawn if your heart and drawing arm are any good. His *Tangier Postcards* from 1967 are no good because they are hopelessly self-conscious and uptight, whereas his debt to Marie Santry, which keeps coming back when he is brilliant, is the heart of his genius.

'There used to be these annual art exhibitions in Sydney, called the Royal Art Society Awards, shown at pubs at

Circular Quay. They were third-grade art shows really. One night, Brett had had a fair bit to drink and he was leaning all over me. He said, "Can I go home with you?" I said, "What's under the coat?" And I discover that he's stolen a painting. It wasn't traditional—it was sort of 3D, with things coming all out of other things. In the centre of it was a big mouth and tongue with hundreds of little and large horrifying bacteria coming off it. He pointed to it and said, "I want to put it over my bed to remind me of what it's like if you've had too much to drink." I took him home on the bus.'

Petra is talking a great deal with her hands, and finger-tips are used to show exactness.

'Years later he revisited that experience at the pub. He called his new picture *Metamorphosis*, but it was based fair and square on that little stolen picture from his teenage years.

'I went to his new exhibition when he was so famous, and he said to me, "How lovely to see you. Every time I go on a binge I can't help casting my mind back all those years, and I remember you and me walking down Pitt Street together to the Quay. We saw a really badly drunken man lying in the gutter and you said, 'If you don't change your ways, you're gonna end up the same as that man lying there'."

'Mum once said that once you learn to draw it's just like composing music. You learn to let it all go, but the structure is still there. You have to learn to throw the structure out. This was the philosophy she used to get movement into life, in respect of her drawings, showing all that movement.

'She used to start to draw in a great big swirl as if she was only ever free when she was drawing. We all used to watch her draw, with the model sitting in front of the fireplace. I was always being painted when I was four years old, by both my mother and my father.

'We had a strange model once, a very large Hungarian lady named Miss Schnable. [I'm told later, by Paul Maloney, that she claimed to be the niece of Arthur Schnable, one of the great pianists of the twentieth century.] She was always sliding up and down cold marble fireplaces using her bottom. Those poses only lasted twenty minutes. Someone would look at their watch and say "Time's up". But usually they weren't sexual models. I grew up thinking of the body as a spiritual form. We're all Adam and Eve in my opinion.

'Roland Wakelin and Lloyd Rees used to come to those life classes, and William Dobell turned up from time to time. They'd have coffee after the drawing. Paul Maloney would come and play piano while people drew. When I was little I met nasty Mr Norman Lindsay. He disgusted me. He was misogynist, pretending to love women, but mocking them so much at the same time.

'To be rebellious I made tailored dresses to get away from them. I grew up in a forest of men and I had to sort of tiptoe to stare up through them and catch a glimpse of sunlight through their heads. Mum encouraged me to draw but said I'd get crushed if I went on with it. I asked her why she tried so hard for me and she said, "If you were an artist, like me, with what I have to go through, you'll end up on drugs."

'I knew Brett until I was nineteen. I only saw him several times after that time, but I know he was on drugs from 1962. Brett really lacked self-esteem, to think that the only way he could draw was to be either drunk or drugged. My mother could easily represent movement, straight. She didn't even need a cup of tea. When I think about it, what did Mum get from him? Here's someone with real talent, someone who's had a terrible time because they've been crushed. Mirka Mora said one day, "Drugs are one expense I don't have to have."

'A girl called Sybilla came to the house once. She won lots of prizes for amazing clay things she made. But when you look at Whiteley's sculptures, they're just like Sybilla's.'

She takes me upstairs to show me all her mother's paintings. One of them depicts Petra as a young girl emerging from a dark background. The stretchers has come away from the frame in the course of the years.

'That's like Whistler,' I suggest. 'Or Sickert.'

'Exactly,' she says, 'It's time she was recognised, don't you think?'

Next to the beautiful portrait of young Petra by her brilliant mother is a perfectly dreadful one done by her conventional father. It obstinately declines to live, no matter how old it is.

PAUL MALONEY IS A PASSIONATE musician—a harpsichordist extraordinaire. I'd put him at 65ish. He's very red in the face and he talks in a kind of speedy vagueness that's very English.

'Well, it was in Longueville that the piano playing started, you know. At the Sketch Club in Northwood that Marie and John ran. No, the Sketch Club wasn't a euphemism; Marie Santry called it that. She'd ask you to come if you wanted to draw from the model. Lloyd Rees and Roland Wakelin used to come. It was quite a thing, you know. George Lawrence, people like him, famous artists like him, rolled along to those quaint classes.

'Ball's Head, they used to go to—a wonderful location landscape—sketching and painting together. I used to go with Rolly Wakelin and we'd sit together in the paddocks painting in the bright sunshine. Marie had a sketch club with a model on Thursday nights. I was doing architecture in a misguided sort of way and Lloyd Rees taught freehand drawing at Sydney Uni.'

The lenses of Paul Maloney's glasses are incredibly thick and he's resting on lots of ancient musical manuscripts. Everything is cigarettes and music. And study. So much study.

'There was a great deal of conversation of a Thursday evening—mostly politics and communism. It got very passionate as they painted, Lloyd Rees carrying on one time, I remember, about bias against Uncle Joe. No one knew about the Stalinist purges at that time, 1956-ish. Those artists were members of the Society of Artists, an important Sydney group. John Santry used to turn up on a Thursday as though he still lived there.'

He laughs and absentmindedly takes rubber bands off rolled up classical music scores. His fingers are like his thoughts, like he's contemplating with his fingers.

'I was seventeen or so when I first started to turn up for those classes. I knew about them because I had met Lloyd Rees's son Alan at the bus stop. You brought your own paper and your own pencils and charcoals. It really was open house and I ended up playing the piano there while they all drew and painted. I used to play Beethoven sonatas and so on. Chopin études and Debussy preludes, that sort of thing … ballades. You'd have to say that that place was the Sydney Heidelberg School, with everybody sitting down and drawing a bit. People smoked as they drew, or they sipped something and argued about politics. You nibbled oatmeal biscuits in a very relaxed manner.

'Wendy Julius used to turn up and eventually she spoke of this boy, Brett. Then one evening she brought him with her. He was about my age and he was astounding. He kept coming after that—each week after he'd knocked off work at his advertising agency, Lintas. I remember how he spoke of girls as pigs— "What I said to this pig or that one … " I'm not sure why.

All of the Northwood Group artists, when we were young, used to chat to each other on the ferry, and the chat was just like we were in the studio. It really was a community, and I was in the group for several years. I went with all those artists to Berry's Bay. (Have you been there?) It was a beaut sunny day, like today actually. I sat in the fields with Roland Wakelin and Lloyd Rees, the majesterial patriarch. You should look at Roland's landscapes because there, you know, you are likely to find the body coming out of the hills—that's something Whiteley probably got from Rolly, probably why he went

painting with him. That's a Roland Wakelin over there, it's me by him. The proportions are all up the putt—he was a very simple sort of man, Rolly. Quite the opposite of Brett, Rolly was. Brett trumpeted his name all over the place.'

All around Paul are paintings and prints, including two portraits of his younger incarnation, one executed by John Santry and the other by Marie. She called herself Marie Forci—I can't say why. He's beautiful in them—young and full of hope—and they're well painted. Marie's is the better of the two and less academic, almost off-hand. A Marie Forli conté drawing of a sleeping cat, so beautifully captured in a few lines, hangs above his single bed.

'From what she tells me,' he says, seeing my appreciation, 'Marie sacrificed her art for her marriage. She had some sort of eye trouble, so outlines were hard, but this she turned into a strength, rather than a hindrance. She was terrific at painting movement. Like to hear the harpsichord?'

He adjusts his spectacles and attacks the harpsichord keys with relaxed panache and relaxed cigarette ash. The sound of it is like a remote cheerful nervous collapse. This franticness proceeds in a loony way for quite a while, whereupon it abruptly ceases, cantatas by Bononcini; Giovanni and Antonio; Alessandro Scarlatti; Telemann and others. The harpsichord is very low, so I can't see it from where I am—I can just see his fingers rapidly stroking the keys, producing a migraine-like tinkle. He returns to where he was before the performance, and gazes at me, smoking anew. He also returns to Northwood.

'That Northwood Group overflowed on Thursdays, people coming and going all the time. It got a name, you know, it really was the place to be. I mean look at that incredible drawing of Sidhu Singh the sitar player who played there. The way that Whiteley captured all the movement.

'You ask whether I think Brett Whiteley should be remembered? Yes, he should be remembered because he was one of our great artists. As I say, that was apparent when I first met him. He was a diligent boy, so what does it matter about the heroin? When I first met him he was like a golden-haired putti—you know, a baby cupid—his eyes were all over the place, intense, darting. His voice was very light—he would have bower-birded people's voices and ideas. My brother Philip hung around with Brett in those teenage years, they were a lot closer than I was. But I know you've asked him for his memories.'

As he accompanies me to Fitzroy Street, he tell me he's a Legion of Mary and he believes in the power of prayer. He's lost, now, in the crowd of junkies and trendies and flint-hard real estate people that make up the new world.

4

It is a fact of life at the Looby household that you are woken at dawn with a jolt, because Keith Looby has hooked up his radio to an amplifier that makes the sherry glasses rattle. You can't help but hear the signature tune for the 6 a.m. ABC news.

When I emerge, Keith's up, drawing cats obsessively. 'Fuckin' ears!' he complains. Each morning he fronts the canvases dressed in a fabulous grey boiler suit encrusted with years worth of thick scabby paint and a few feathers curling in his hair to top it off. A workmanlike approach to art has paid him dividends. In 1984 he cracked an Archibald Prize with his painting of comic actor Max Gillies got up as Bob Hawke, which is just like both of them.

I sit in the bantam enclosure next to Keith, who is in a sort of mesmeric trance, leisurely stroking glazes of turpsy washes over thick scumbled rectangular and triangular shapes. It's rather hard to see him, as he is all dustcoat. He has unconvincingly smooth, youthful hands that alternately squeeze enormous

the artists' artist

plops of oil paint onto stern hog's-hair brushes then spread the message of cubism across chasms of cobalt. The figures he is painting seem trapped uncomplainingly in the tranquil confines of abstraction, forced to harmonise by Keith's meditative early-morning meanderings. He does these portraits from Polaroids with coloured Textas; they're not bad. Look what Whiteley's missing out on— the incredible beautiful morning sun, warming Keith and me as he draws a cat and I watch him draw.

It is peaceful to share the morning with an artist of fame and a historian of hearsay. Looby loves to stir the possum and enjoys his enemies in the arts as other mortals enjoy a timid egg on toast. He is sixty but looks more or less, depending on how late the nights, and his voice is an insistent whine.

It is ambiguously claustrophobic in here with Keith; I feel cramped as well as free. He has held lots of sell-out exhibitions, but there is something narky about him. He puffs cumulonimbus cigarette smoke up towards the low ceiling.

'To get on, you have to really push. I didn't go for that. My old man I admired 'cos he was out of work for six years during the Depression. They either jumped off the Harbour Bridge or joined the Communist Party, which he did in 38.'

Keith was drinking with some artists from the National Art School at the Newcastle Hotel when he first encountered Brett Whiteley. 'He turned to me and accused me of knocking off his schooner. One of his mates said, realising he'd made a mistake, "Here's your schooner here, Brett."'

Looby said, 'How about an apology?' and Whiteley challenged him to a punch-up outside. 'All we done was want to kick each other,' Keith said. 'Anyway, out in the street, he still wouldn't say sorry.

'He put me in mind of me brothers' friends. A real toffee apple. A real Ivy Leaguer in tweedy jacket and alligator shoes. A real sports-car nut. He was working for this posh Sydney advertising crowd called Lintas, drawing Boeings and E-type Jaguars. That's where he developed his famous inimitable fucking curve, drawing E-types and sheilas on beaches.

'Anyway, a few weeks later Mick Johnson the artist had a dinner at the Greeks. Whiteley was there with Mick, and he reached across to me and reckoned we'd be friends. He seemed insecure. His voice changed too, as well as him. The voice changed to suit the situation—the intonation, it changed with the lingo.'

Brett's line

By the time Whiteley left the ad agency Lintas, he had already plagiarised a fantastic line. It was the sweep of the line that wooed him, like the sweep of elliptical china dinner sets as portrayed in the *Women's Weekly* and other mass-circulation glossies. He'd perfected what you might call an extremely cautious spontaneity. And so, armed with an elegant British Airways or Alitalia Line, the kind of Panache Line used to depict jets and speedboats for high-quality reproduction in superior airline magazines, he knocked off and made his own beautiful sweeping line, a line that lasted him forty years. He was so good with it that no one could get near him. He always had this great line. And the line was good to him. It was his oxygen line. He employed it tirelessly when he went about the strange work of tracing currents in streams, diving for it like a porpoise through rippling waterweeds. Waves, entanglements, engnarlments— with this swag of lines upon his freckled back, he had all he ever needed to go forth and conquer the world. And he did.

Keith sips a mug of stone-cold tea and smokes, staring hard at his painting, a series of oblongs that mysteriously make up a group of cubed people with huge enquiring cartoonish eyes and overblown infantile hands. He rapidly swishes his brushes in a rusty jam tin of dirty old turps. He's contentedly nettled.

In 1960, when Keith was twenty, he went overseas and hitchhiked around Europe. 'A mob of teachers from the Push came to Turin and taught English to the industrial triangle.

There were some very beautiful girls there. There was just so much going on. I saw Jeffrey Smart and Justin O'Brien. Whiteley lied when he said that he was the first Australian artist to make it in Italy.

'In 1961 I was on my way to Ireland, and my mate Ross Morrow and Brett Whiteley at that time were the youngest contemporary artists in the first international showing of modern Australian art at the Whitechapel Gallery in London. Ross Morrow was very anti self-expressionism. His work looked like tea-towels to me. But he'd approve of that insult of mine—he'd have a proper laugh at himself. That is a thing Whiteley could never do. Whiteley was more precocious than the rest of us. He never really made it big-time like Sid Nolan or Arthur Boyd, but he was very ambitious. Whenever you tried to talk to him he spoke almost entirely about himself. What percentage of himself did he not speak about? Fuck-all.

'Whiteley's admirers honestly believed he was at the forefront of the cutting edge, but really he was just good at PR. He needed total admiration all the time. But it hinges on paranoia when you can't take a single word of negative criticism.'

Keith remembers when Whiteley went hippie in London. 'It was a total change of character. This was when I was in Italy for two or three years—during the "Hey, man, it's all happening" generation. He went straight from flashy advertising kid, real up-himself jerk, to London-based hippie. He's not the only one to have stayed at the Chelsea Hotel; I stayed there too. But by that time it was getting a bit fashionable.

'As for his dramatic use of mind-altering drugs in preference to booze, once he was at a party with John Firth-Smith, the artist—Firth-Smith was the first of the Lavender Bay mob—and someone said to Whiteley, "Do you want any of these LSD tablets?" Whiteley said, "Don't mind if I do, man," but when no one was looking he tipped 'em down the sink.'

Artist on the international stage

English criticism at the time said he was skating superficially over the subject matter, using Bonnard and Bacon to overwhelm the viewer, as if the student painter is conquered continually by the flashiness and charms of surface appearances. Is that all he's after?

Whiteley writes to Bacon on the advice of the savage master of the macabre, citing the advice from Bacon 'Just go and do it'. He is after his own solution to crisis or horror captured in imagery. He borrows Bacon a very long time, keeps him there in his back pocket so to speak, handy to have the right famous style on you at the zoo or whatever. Hundreds of artists in his pockets.

Robert Hughes loved him then, in the early 1960s, and said every painting he does is like a roll in the hay with the muse of art history. But the truth is that by this stage of his development he has become too many famous artists all at once, so it is impossible to see which one he really was or is. Matisse a bit. Pollock a bit. He head-butts others, bullhorns them, encircles influences, batters them into his own submission. Is he an

Australian in Europe or a thousand European and American artists all painting side by side? A hall of mirrors—magician? He paints poverty, sculpts it from the horror of Indian poverty, something great is much missed. What is it but truth? Can poverty be taught without the songs of experience?

Triptychs of Francis Bacon are beautiful-sounding and history-sounding but aren't much chop if all they do is look just like quickies out of some advertising agency brochure.

It's the majesty of the famous name and the one-upmanship that he is after, rather than the chance discovery of any feeling in the work.

But of course the work of art is to look for feeling. Bacon executed what he later felt were follies—his own crummy homages to Vincent van Gogh but which for a moment caused Whiteley to hit the anchors.

Keith Looby shoves his brushes into the turps tin, creakily stands up and escorts the new painting gently indoors. He puts the kettle on and tips teabags into cups. He surgically undoes a bottle of stout from the bench, and we drink stout and smoke out on the veranda. The dustcoat hangs solemnly from the back door; April Looby says she'll skin him if he wears it inside.

The Loobys are sweet and hospitable people. I'm sharing their attic with a painter called Ric Abel, a cheerful sort of bloke. Ric paints ultra-realistic portraits of Mr Squiggle set inside all sorts of famous classical paintings. The wonderful Mr

Abel has translated Dali's surreal picture of Christ on the cross into a crucified Mr Squiggle and has reworked Goya's paintings of firing squads so that it's the hapless Mr Squiggle who is being shot. He paints with a superb finish and an astonishing eye for detail and casts Mr Squiggle in a completely new light.

It's Sunday morning, so Keith, Ric and I take the train over to the city to listen to the speakers in the Domain. First, though, Keith wants to take me on a pilgrimage to a pub where the Sydney Push used to drink and quarrel. We have a lot of trouble finding it, because the old part of Sydney is just about gone. Keith keeps saying 'It's near the Quay somewhere.' After what feels like hours traipsing through the windy wilderness of Sydney's financial zone, Keith finds what he's been looking for. I expect him to kneel and cry 'Halleluja!'

But can this really be it? This is just a yuppie bus-stop— a slick, renovated pub full of macho stock-exchange types. Any trace of bohemianism has been faithfully vacuumed away, but we press on anyway and buy a few jars. Keith discovers a metre-long piece of old polished bar counter with a plaque saying 'The Push Drank Here'. 'Germaine Greer and Bob Hughes leant on this wood, Dickins,' Keith reminds me, stroking the bar as if to bring back the past. How do you buff that up?

After a while we wander off to Hyde Park. Eventually Keith wanders off to listen to the speakers, among them an old commie—possibly the last com in Oz. I'm left gazing up at the Moreton Bay fig trees. They look as solid as stone cathedrals, so permanent, so colossal. The breeze picks up, and I can hear it

eavesdrop in their leaves. The trees' roots are like elephants' toes, or dragons' claws, or griffins. They remind me of the power and sensuousness of Whiteley's Moreton Bay fig, the ink lines indicating all those yearning years of coiling growth, dark grainy ageing. Just like a sincere child, he sketched the million leaves all curling up and travelling different ways. The longing limbs and flashily lit twigs on the end of them. He loved those trees; he befriended them, trusted only them, hugged them, spoke to them, in a state of rapture higher than he could obtain from drugs. Their grip on life was a revelation to him. Temporarily the trees saved him from himself.

FELLOW ARTIST GARY SHEAD chats with me about Whiteley, remembering watching him work: 'He was all at once. That's the way he was. All at once. His energy was remarkable. He drew speedily. He didn't ponder. The whole drawing thing by him was quite balletic. It involved dancing, standing back and posing—not in a whirling dervish way, but striking poses. Not self-consciously—a beautiful style, it was. He was aware he was performing. Out to make his mark.

'He worked constantly. You'd go past his studio at four in the morning and the light was always on. From what I remember, there was always something going on.'

The painter Peter Kingston, who was Whiteley's neighbour in Lavender Bay, confirms: 'You had to admire him—you know what I mean? He used to swing onto my balcony like a chimpanzee, then swing along the wrought-iron terrace. The

one thing to remember about Brett is that he was absolutely fearless. You're looking at a sixty-foot drop down onto the path, and he swung up to me in this weird way just because he felt like it he. I can still see him sitting under that palm tree down there, painting his toenails, with a Japanese kimono on.'

I remember a photograph of Brett Whiteley that Mirka Mora showed me. In it we see Whiteley assuming the persona of a circus trapeze artist swinging on a thick rope, wearing only a pair of calypso silk striped pants. When the rope reached the height of its arc, he added a painted highlight to a huge bulbous papier-mâché nose of Rembrandt, making the old Dutch master resemble some kind of gaudy Luna Park caricature of his former greatness.

I also remember Whiteley telling Rudi Krausman, in a 1975–76 interview for *Aspect* magazine, that he had a terror of nothing. 'Everything is in a state of flux,' he proclaimed, 'everything seems to be gyrating out from an invisible point of silence, all movements, motions, actions, seem circular, an endless and inexplicably beautiful system rotating around the terror of nothing.' He went on to explain that for him 'fear is death's art'.

And I'm just thinking that I know of at least one fear that he did have: the horror of boredom. Otherwise, why would he have multiple television sets welded together and leave them blaring away off the station to create sufficient noise pollution to enable him to paint in perfect chaotic peace, as it were?

While I'm remembering and thinking these things, Peter Kingston reconsiders his last statement. He tells me how

Whiteley would have great clumps of oil-soaked money lying around his studio. 'There was one thing that terrified Brett,' he says. 'It was the prospect of being without money.'

Gary Shead tells me how Whiteley was a Bohemian when he first met him in 1971. 'He had doves on his front verandah, as a homage to Pablo Picasso. He had their cage netted off and you heard them cooing as you went up. Many doves, there were. About a dozen. He didn't paint them; he just wanted something beautiful to look at, you know?'

'He had to assert his mark on the Lavender Bay house when he got home from Fiji. Something emblematic had to be done at once. He adhered a huge painted frangipani on the front door as a symbol of Sydney. He did beautiful drawings of nature, particularly of flowers, with that beautiful free line of his.

'During the 60s Pop Art period he just did it extremely well, influenced by Rauchenberg—The Americans—anybody really. There was a nimble skipping across styles. He was brilliant at that period of his life. He said Van Gogh's drawings influenced him the most. He became un-influenceable down the track, towards the end of it.

'In New York, where he spent some time on his way home to Sydney from Fiji, he'd blown his mind on the American Dream. He and Wendy had lived in a hut in the mountains of Fiji, doing a few drugs, not living with white people. He was trying to do a Gauguin trip.

'He came from the commercial art world. He believed you had to put on a special show, a great show—you've got to

make the most of it … it's a spectacle, you know? His opening nights came with a great theatricality. There were flowers and incense and Wendy brought out the food. It was all luscious then.'

'Did he turn up at any talented younger artists' shows? I ask.

'Only to rob! He'd show up there only to rob ideas. He said "Great Painters steal; ordinary ones copy."'

'Do you know the one about the pair of binoculars? He kept a pair of binoculars in his studio beside his chair and he always looked through them the wrong way, to see how the picture would look reproduced or how it'd look in a gallery later on. So he microscoped them.

'His skills were just fantastic at parties in the seventies. A great monologuist. The topics would encompass everything there is. Life and art. He mightn't make much sense but he'd convince you that you were listening to the greatest truth of all time. I didn't know what he'd been on. Speed at that time, I think. Speed is a brainstorming drug, so it had to be speed in the very early 70s. But in 72 he was on heroin. The work on heroin was obsessed with cleanliness and bright white. Whiteness- and hygiene-obsessed, he was, on heroin. He wasn't as chatty then. I lost touch with him.

'The last time I saw him he was in Raper Street, where they've established his museum. That was his old studio and he had invited Bob Hawke, as he just wanted to be with the Prime Minister. He didn't want anything to do with me. He was still

charming, though. He was always charming ... and funny—at his best he was just so funny. One time we were down in Darlinghurst, going up the stairs of a restaurant. Someone had put rocks all over the stairs and Brett said to the waiter: "Are you expecting a cyclone?"'

'Brett', the show

For Whiteley the whole idea of exhibition openings was to overwhelm, conquer completely any skerrick of reserve held by the art-adoring general public. The painting- and print- and sculpture-acquiring general public became intimates of the avant-garde and assumed an automatic intimacy with the leader of the push, for such was Whiteley. When he raided Francis Bacon they slavered for his take on FB.

When he organised his gallery openings he saw to it that everything was in perfect taste. This was quite simple because he had perfect taste. When he was old he fumbled it and lost it and recopied his crummy junk. But when young the opening nights at his shows were all-conquering, a victory for mesmerism and curry puffs. Brett's bearing and bell-bottom white slacks, and perfume and talk and kidding, were so far ahead of any possible rival in the arts. He was a cut above the purest silk and his words were also of purest silk. It was inconceivable he may slip. The nouveau riche adored the silken carpets he preened himself upon. They hung upon every word of spontaneous wit that fountained. Seventy years after the suicide of Oscar Wilde he raided him also: he spoke affectedly like Oscar,

but seduced like him as well, to great effect.

People were simply awed and brained by Brett Whiteley and he conquered whomsoever he met at openings, like the press or lesser artists or caterers. He fetched great stunning charm into gossip plates for tableau press and tableau telly and chatback radio controlled by morons. As with his gruesome pro-rape Doctor Christie series and the Bonnardesque 'Wendy in the Bath' masterpieces, he upstaged all with unteachable panache. He was like a stoned high-speed signwriter. A demonised decorator.

Brett Whiteley was the Errol Flynn of art in Australia but not Hollywood. He enjoyed fame and strove hard to be noticed. Not being noticed is anathema to brilliant artists, so he made it a dead cert he got noticed. The public are shy. They aren't noticed, even dead. Their graves aren't interesting or beautifully designed. Their tombstones say nothing, just as their once-living bodies said nothing upon the earth. They need a leader. In his time, Whiteley was it.

IT WAS 1976 WHEN Jenny Driscoll, long-time partner of poet and songwriter Michael Driscoll, met Wendy Whiteley, who used to come to Michael's gigs in Balmain— 'Little smoky rooms where Michael sang songs about Rimbaud, love and William Blake.'

'All these people who came seemed so confident of themselves,' she remembers, chatting with me in a dim burger joint in Geelong. 'It was a bit scary for me. But Michael just

moved in that circle. A love of words and quick spiralling repartee is what he shared with Brett. They were really close like that for eighteen years. Brett inscribed the Sandra McGrath book he gave Michael with *For Michael, for the special brotherhood, love Brett.*' That was how Jenny knew Brett.

She has brought photos to show me. 'Here's Wendy. Now look at that! She was incredibly beautiful.'

'And here's Brett: he always made a statement, struck a pose. He'd put on some touch to look unique, some Zen adornment—a cowry shell, a frangipani flower, the cut-out circle of an Aboriginal flag, statements about death stencilled on T-shirts. He expected to be noticed and had tremendous energy and charm but quickly got bored. In anyone he met his cartoonist's eye unerringly found the unique characteristic—he'd check out the chicks in the Hill End pub and instantly have a nickname for each—buckteeth Jane and so on. He sometimes referred to himself as a bowerbird, bringing home the prize to win admiration, to win the lady, impressing her with his creation. The creation of the amazing-ness of his view of reality, his art, his very self. "I've invented myself," he'd say. This impetus required that he step outside boundaries, that he needed something every day to just shift the consciousness a bit.

'He was aware of his talent and wanted it to have the best arena, the best bower. Sitting in his studio at Circular Quay, Brett once told Michael and me that as a young man he had heard God's voice. He was firing on with the muse, painting, when he said, "I heard this voice and I knew it was God, saying,

'I want you to use that talent for my boy', meaning Jesus. He said, 'No, it's all been done. Piero della Francesca and Michelangelo have left nothing new for me to do.'"'

The reminiscences come spilling out of her as she speaks of him with warmth.

'Brett used to come up to Hill End, three hours from Sydney, to come down and sometimes paint. We had moved there from Redfern and become quite self-sufficient. I grew all our vegetables and fruit—even raspberries—and Michael shot wild duck, kid and rabbits. Brett would ring and say, "I'm coming up." He'd bring such delightful rarities as French cheeses, special breads and Johnnie Walker. He was so hearty and generous and loving, and we had the finest gourmet meals out there in the hills. We'd go rambling along the old creek bed before talking long into the night. I had Old English bantams, which he had helped me select, and when he stayed he used to pat them and say "nigh-night" to them.

'He'd stay three days or a week. Once he shut himself up in his room for two whole days with just a big bottle of water and a large bottle of Coke. "Don't talk to me," he said, "leave me alone." In a sense he was putting himself in jail. "You have to do it," he told me. "It's a flirtation with death, so it's going to take days this time. I'll come better and I'll see you after that." He honestly felt he deserved to be punished because he derived such pleasure from heroin. When he was drying out like this it was very painful and he'd look all blanched and malaria-like. Yet he was well aware of the relief he could have got with a doctor's prescription.'

Then she adds to the growing list of Brett's fears—this one refreshingly mortal: 'I remember him being real scared of catching sun cancer at the beach. He would be dressed in gloves and a long-sleeved black T-shirt and long trousers, sitting on the beach under a big black cloth umbrella. He looked pretty funny in that black garb, covered in shell grit!'

A magic window

Whiteley's ultra-romantic *Tuscany I* (1977) is a work of sheerest breathtaking nobility. It offers many homages to art nouveau and art deco and Edvard Munch and Lloyd Rees for all its strange cypress trees and cadmium orange paths that lead the mind-boggled viewer up a large garden trail that is sinister swirly hills topped with macabre holocaustian clouds and Van Gogh-ian fields that shine and shiver between strange arrivals of sweeping blackbirds. It is serious comic art that is so utterly alive to the fact of its energy and new designs that it seems to lunge forward at you. The idyllic bony hills continue forevermore into both a lurid emerald sky and a kind of sculptured hopeful one. Nothing in the history of art has been done quite like *Tuscany* I. It is a coming together of river-y shivery reflections and opaque running-out-of-breath hilly clouds, formed out of vast impatience in a frenzy of hectic loving care.

The wonder of this painting is that it is so completely seductive and involving for all its overt as well as insider tributes to history's greatest painters. You detect Braque in the bushes and Van Gogh in the fields and although it is vast, at

210.9 by 259.1 centimetres, it also looks like a little secret conjurer's window through which the magic of the world beckons dreamily and cunningly. Knowingly of God. Painted with pots of money and real Renaissance style.

ONE FRIEND WHO HAD a strong hold over Whiteley, sticking right by him, was Joel Elenberg. He was a sculptor who carved wondrous figures from white-speckled marble, which he fluked from graveyards or found in paddocks. He used to chain-smoke an incredibly strong cigarette tobacco called White Ox, which was to kill him.

When Joel died of cancer in Bali, Brett drew him right on the cusp of oblivion the very second Joel went to paradise. It was a beautiful thing to do and think.

In downtown Melbourne I spoke to Joel's widow, Anna, who remembers how Whiteley responded when she told him, during one of his visits, that her little daughter was distressed at losing her young father. 'Whiteley ran all the way to Myers in Lonsdale Street and forked out every buck he could find in his pants to buy my little grieving girl the most splendid sparkling brand-new red bicycle to have some fun on.

'He was happy to spend all day long chasing my daughter around on her new bike. He was screaming and yelling and absolutely determined to make her forget her sorrows. Brett chased the grief out in that park that day—I'll never forget it till the day I die. He was just so kind and considerate. Boy! Did he run after her and play the fool for her!'

Asher and Luba Bilu are also old friends of Brett. Asher is an artist and Luba runs a Melbourne gallery. I visit them at their home and ask Asher how he first met Brett.

'It was in a house in Nottinghill, London, forty-something years ago. I had a show at the Rowan Gallery, a one-man show—bit of a coup actually, that show. The gallery became one of the most successful in London.

'I was twenty-eight or twenty-nine at that stage, I suppose. I had just moved in there and was sort of the new kid on the block. He was among a bunch of younger artists in an adjoining room, all talking full pelt about art—American art and goings-on—in a kind of faction war between the pro-minimalists and the colourfield people—people like Frank Stella, Nolan, the American–Russian thing with Barnett Newman— and it was a very heated discussion. I was lying in the bath, with a plywood partition between me and them, listening to the conversation, when Brett just walked in and used the toilet right next to me. He was your typical little tenacious ankle-biter, with shortish hair back then, before the trademark Afro all-sticking-out-thing that he copied.

'This house was actually Peter Upward's studio. He was going back to Oz. I had to move out of Putney and I was going back to Oz, too. This was just an interim sort of arrangement. It was pretty run-down, that place: just a corner house, no garden. Strewn on the floor were art magazines, which the group in the house devoured. They were just so caught up in the latest styles, the current fads, slavishly so.

'I mean, Whiteley attempted abstract expressionism but not long afterwards he became figurative. He always said he wanted to do a really good abstract painting. It's something he couldn't do, though. It was definitely a challenge.

'He invented as he went along, but he always had his own style. He said that painters have a bag of tricks and that he had about half a dozen styles he could draw on, half a dozen different approaches, different ammunition. I've got that as well. You can always come back to it. Last year I did a painting in a style I hadn't painted in for fifteen years or so.'

Lost in a sea of contradicting styles

Many years ago when I toiled in television for Channel 7 at their mouldy old scenery bay in South Melbourne, between 1968 and 1970, the daily work required me to nimbly hotfoot it up vast rickety stepladders and scaffolds. And there, poised high atop squeaky pine planks, I painted. I painted anything: forests, skyscrapers ... you name it. We used six-inch brushes mostly and great big real sea sponges and even strange devices with which to render rococo wallpaper if the setting needed an eighteenth-century look.

In short, two years worth of frantically painting practically everything in and out of our world did me a heap of good. One day, and this puts me in mind of Whiteley, my boss Harald Vike was discovered by myself seemingly meditating behind a whole stack of gigantic 40-foot- long canvas flats— upside-down, he was, with his great big calloused thumbs

entwined within a banana-bunch of thick fingers behind his hairy ears—and he said to me: 'I'm lost in a sea of styles. I can paint like Matisse but not like me again or any more.'

Indeed, Harald could imitate any painter in history merely by internally copying the style, then externally reproducing it on a canvas flat. If he thought like Dali he painted just like Dali. He thought like Albert Namatjira then did a desert landscape like him.

Identifying with Christie

Perhaps Whiteley painted best, for all his influences, with the erotically wicked Doctor John paintings because he is on the record as saying he felt sorry for him—and he has to be the only human who ever did. Christie it was who enjoyed gassing ladies of low repute and raping their corpses after a decent garrotting, then bunging them in behind globulous appalling damp wallpaper in his corridor at infamous 10 Rillington Place in London.

Whiteley, living nearby, checked out the grisly cottage of the eventually hanged Christie and swatted up, as earnest scholars do, on this bizarre gentleman. Then, just after creating a storm with his 'Wendy in the Bath' pictures, he came up with possibly the only pictures in art history to sympathise with rape and murder and frenzied longing for woman and paranoid understanding.

You understand, when you look at this ghastly series, the sympathy for madness that is inexpressible outside prayer. If

children should have nightmares then these are the pictures that take them to the movies. They are collages congratulating depravity and death and remorseless slaughter.

Torn bits of mattresses abed with Francis Baconry. Gimmickry and revolting subject matter set to shock, guaranteed to jolt, intended to make famous and did. But what did Whiteley feel while painting them? Anything or something? Fury at an indifferent universe or justification that lunatics like Christie are also his friends of the indifferent oil paints and avuncular easel.

When the English Establishment hanged Christie they actually murdered him because capital punishment is homicide with the State on side, the Church on side, the press on side. Whiteley doesn't feel sorry for Christie in the series, but shows the hyena howl of what society is capable of doing in respect of its extreme outsiders.

Could Christie have reformed if he was spared the rope? It's too late after the sentencing magistrate points the bone.

Whiteley says in respect of the evil manifest in the John Christie paintings that he feels afraid on all levels, from Christie to the White House. It becomes a pathological art possible to depict Hectorina McLennan, one of Christie's victims, holding a gas-mask before her mouth and a frenzied rape to follow plus the slaying. Is this deed evil as well as pathetic, is it insanity as well as art?

'When I left London he went to New York. The first time I saw a body of his work was in Sydney. He and Wendy had just

got in from Fiji and he'd set up his house in Sydney. I saw his work at Lavender Bay. His "Blue Harbour" paintings became so popular that all he had to do was knock out another one of them and he'd be guaranteed another fresh sale.'

Asher Bilu lies pretty much naked on a divan, with reading spectacles on his proboscis, shuffling round to get comfortable on a forty-degree Melbourne mid-afternoon. The big sunroom is crowned with his inimitable abstracts and tiny photographs of himself and family, as well as framed silver portraits of Luba as a beautiful young woman and all sorts of lovely family snapshots.

'I remember his dogs very well. In those days he drove a Mini Moke, with his two dogs always in it wherever he went. That was his trademark in Sydney. He was always chatting to the dogs, laughing with them or disagreeing with them.

'When he spoke, it was just poetry in motion, unlike anyone else I've ever met: existentialist but provocative and playful, talking non-stop, commenting on anything he looked at. He spoke unpredictably; like little gems, his words were. It's not just a couple of words you remember, but a whirling of them, describing any situation. It would be breathtaking. His incredible language is what you miss and therefore remember. In his interviews in an abstract fashion, it was real music for me.

'And what about his laughter?' I ask.

'His laugh wasn't a pronounced one. I know this is going to sound outrageous but his laugh was like a squeaky bed. He was always a master celebrator of life and his humour,

black or whatever, was always evident.'

I ask Asher whether he was aware of the point at which Whiteley descended into smack.

'Oh, yes. We stayed at John Laws' place one time. Laws' home was stacked with books he'd never read: row upon row of unread impressive volumes given to him because of his radio show. The girls—Wendy and Luba—went off somewhere, and Brett was stuck all day in Laws' recording studio. Somehow he couldn't extricate himself from it. He spent hours perspiring in it, trying to get out, and he was climbing up the walls, hanging out to score.

'This was what it was like to need it and not have it. He was running hot; they always do. He was always off to score. She was like a Queen Bee. I remember some pretty hairy situations around this time. Scoring is very much part of the excitement. When you are on it, some part of it or you wants to give up and you never think rationally.

'I wouldn't use the term *high on heroin*; it is just sort of normal. The impetus is to be normal, not high. If you take it, you just sort of feel good. I did three hours of yoga this morning and I feel high. A rush of well-being for the first shot. But where do you go from there? When things get too much for you, what do you do? You get a rush of silence. A noise becomes peaceful. Everything is manageable and nothing is too nasty.

'His daughter Arkie was six or seven at this stage. She was remarkable, with a command of world issues, walking alongside her father on the beach, making the points she

wished to. She was a highly intelligent little girl. On all the late night stays I did when I was there in Sydney, we were with all these odd-bods and free-loaders sipping drinks and nibbling nuts—you know, people people people everywhere—and Arkie would be running between the pillows and giant cushions designed and made by Wendy on the floor, completely at her ease. She'd be darting among the people, chatting to them about polio or world situations at the age of six! I ask you! We always had a good time, laughing ourselves stupid.

'A golden time, it was, for Brett when Wendy was away in London and his girlfriend, Janice Spencer, was with him. If Wendy was there, too, with one flick she made Janice disappear. With Spencer, Brett was different: he was serious about her. He wanted divorce from Wendy.

'The masturbation painting he left for Janice after his death—a beautiful painting—he did it trying to be erotic. I'm not a great fan of his bum paintings and his tit paintings. I remember walking into his studio, after he had become very famous and successful, and seeing a whole series of anal penetration works of absolutely furious fucking and pumping. He had masses of porno magazines from which he took his erotic ideas and he'd do them in close-up. I thought, as I gazed: what are you adding to humanity?

'He never went to Zambia, where monkeys were everywhere. All he had to do was snip up hundreds of glossy monkey photos from *National Geographic* magazine and cut straight to the monkey chase.

'I once bought Brett a gift because he had written a beautiful introduction to a book on my paintings. It was a wonderful carved giant wooden paintbrush which I found advertising artwork outside a Tokyo paintbrush shop that was hundreds of years old. Complete with stunning curved hairs, it was almost two metres long. I posted it to Brett, who was in New York at the time, and I never heard a word back from him about my gift of gratitude. I didn't really worry about it much; I just trusted that he liked it, you know.

'I saw him again in Sydney where he was having another sell-out exhibition, where his pictures sold for six or more times what mine realised. I asked him whether he got the present I sent him from that obscure paintbrush shop in Tokyo and he replied, "Sure I did. Thank god it wasn't one of your paintings."

Asher Bilu looks philosophical enough, as if it's just a tease of his old fellow artist but there is an element of hurt in his expression, as if to say 'He was like that, so what can one do?'

He manages a smile and out we stroll into the courtyard filled with his sculptures, which include a tribute to the doomed who perished during the World Trade Center catastrophe.

Then it's Luba's turn to remember Brett. She tells me how, late one night after taking her and Asher to dinner at a Sydney restaurant, where they 'had a lot of fun … a lot of drinking (Wendy and Brett were always fun)', Whiteley was

desperate 'to receive attention when Wendy was telling a story [so he] repeatedly charged head-first into a brick wall, really hard … Knocked himself fucking stupid.'

In no time, Luba is going like a rocket, full of atrocious and ruinous chronicles about Whiteley. 'He was always talking about meeting "the Man"—one of those great big thugs preying on middle-class junkies. These criminals are always in black as though there's no hope in them—and there is no hope in them. That same night, Brett took us all into these burnt-out Sydney back-street buildings, running up and down scorching stairwells with missing steps in them, looking for "the Man", for God sakes.'

Asher takes up the story, waving his hands at me in their sitting room, where I am overshadowed by Whiteleys and a massive Elenberg that is a wonderful silhouetted three-dimensional iron sculpture of a dreaming face.

'All he wanted really was the excitement, you know, the hunt, the thrill of the hunt, even more than the heroin. It was incredibly dangerous what he was doing—I mean he was much too old to be doing this sort of stuff—but he was in a lather of *Boys' Own* adventurousness.

'Once, when Brett ran out of petrol, he lifted up the bonnet of his car over the road from the building where the drug dealers were. He ended up getting a mouthful of petrol out of the carburettor. The petrol was falling out of his mouth and he was standing there screaming, laughing.'

Luba interrupts: 'He thought it was funny chasing

around after these really sick people. For him it was a fantasy, but we could have all been killed. He just never grew up—although I have to say, when Janice and Brett stayed here in 1979, Janice had got him off heroin, and I'd never known him to be so calm and pleasant and sweet and peaceful. They got on it again on that stay, though, and they were just so edgy. They were trying to look straight, but they were exaggerating everything for effect—hyper. In the end, they just had to go, I suppose because they didn't want to use junk in front of us.'

Eros writ large

It is an on-going obsessional demand he made on his wits to seek to capture the sexuality of all that lives. Frangipani sensuality and ocean wave erotically and unnervingly delivered by beachside steel nib. He is the scientist-with-brush squinting into a kind of reverse or backwards microscope revealing the artistic fact that twigs and limbs of swaying trees can easily pass for the insistence of lovers' fingertips and toes that slaver for satisfaction. Refreshment and liberation. All his beauty is available through one world and that world really is his drawing.

The 1960s mixed-media pictures are fearlessly and swiftly executed with gutsy dash and charge that seems to overhear the collapse of the charcoal and franticness of ink splurging into gouache and fifty other squiggles. It's as though he wants the medium to be about fight. This dynamic line ramming that living channel of blue. The great live line visible

like a vertebrae beneath the talking-to-themselves whirls of big brushed buttock or leg. Everything is balls and attacking explosions that decline to sit still.

He enjoyed painting swinging apes to the hysterical strains of Screaming Lord Sutch. Thinking, he thought, like Henri Matisse. Henri Matisse who was thinking like Masaccio, in the end drawing in a whirlpool—all of them.

It must have seemed the logical requirement of an avant-garde artist to be political as well as sensual. Can you be politically sensual? One wonders.

5

I'm surrounded by Dutch backpackers and super-eager Virgin Blue customer analysts who are quietly interrogating unconscious travellers about whether they got to the airport by bus or private car. Bald young men flexing astonishing biceps—are they terrorists or members of an insomniac soccer team?

I've brought Tim Robertson's memoir of the Pram Factory theatre to read in flight. I'm just settling down for a read when another Pram Factory survivor, the eccentric bassoonist George Dreyfus, sits down next to me with his young son.

George screams. Screaming is the way he converses. 'Why did So-and-so marry that English bitch?' I've got no idea, George. He cackles upsettingly.

There's an announcement over the intercom: the flight will be delayed by an hour and a bit. Everybody sighs.

George grabs the book from my hand, glances at it and chucks it back where it came from. 'It's hard to look people up, because it doesn't have an

a few extraterrestrials

index.' It does, George, if you care to look.

Brett was fifty-three when he died, and I've just turned fifty-two. I wonder whether we would have got on, or would he have been too demonic?

It will be sunny in Sydney, I know it. I eagerly chew my barley sugar and start to wake up at last. It's like swimming through cotton wool. I can neither sleep nor wake. Who cares? Soon Brett Whiteley will have been dead for ten years. Again, who cares?

THURSDAY MORNING by bus to Wendy's at Lavender Bay. It's a bleak morning hayride with everyone off to Purgatory or Work. The people on the bus probably don't have anything to do with artists, except when they flick-read about them in glossy magazines.

Right in front of me a suicidal schoolboy is playing with his locker key. His eyes seem dead. Is this his dead father next to him, fiddling with a

rainbow-coloured pencil? He seems to be writing in his diary; it appears to be all his rules for the day. Being an appalling stickybeak, I bend to read what he's writing, upside-down. It says 'Don't Forget To Read To My Son'.

The schoolboy jumps up—he obviously knows his stop—and lurches towards the front of the hearse, his eyes just as leaden as ever. Off he gets, and the father doesn't show a thing, if he is his father.

Where does human oddity start and conventional appearance end? Where do painters get their inspiration? Maybe from places like this. I guess there's a story everywhere.

At last the bus stops at North Sydney. I get off and sit for a moment on a friendly 1920s park bench in a miniature public park on a corner, looking up and through Whiteley's beloved Moreton Bay fig trees. Dark and moody things they are, but patched with reassuring light. Beside them old, dark, red-brick blocks of flats face the wavy blue water—a glimpse of Sydney Harbour. I could sit here for a year, easily, and wait for Whiteley. He'd come for the trees.

What will Wendy tell me about Brett? Shall we speak of his love of creatures, of his fixation with waves and water-currents and their secret energies? I'd like Wendy to tell me about how he drew and painted, the way of inks and brushes and the love of control before he lost it.

Wendy asks me if I'd like bacon and eggs. 'Sunny-side up coming up.' She looks on top of the world.

Her phone rings all the time. She's always going out,

always arranging to pick up friends from the airport. There's always a show or a speech.

I ask her about Whiteley's love of the natural world, the energies contained in stars and water.

'He instinctively recognised the interconnectedness of all things,' she says, sounding just like him. 'Certain forms, such as waves in front of him, attracted him. He had an enormous fondness for birds. He drew and painted a semi-caricatured bird that he said was himself—a bird in flight. He caricatured himself often that way. It was a self-parodying bird. The self-identification … somehow it struck him as a great escape to be a bird.' She shakes with glee, and her eyes open up wide. 'You could piss off without getting into trouble. You don't have to front anybody. He was brilliant at pissing off.'

Hers is a hearty, croaky laugh. She loves to joke.

'He had an obsession with Vincent van Gogh. Good and evil, sane and insane—he was always figuring out the psychology of Vincent. He'd seen Vincent's pictures blown up to cinema size. It was overpowering. "Another Way Of Looking", Brett's Van Gogh show was called. It was shown here at the New South Wales Art Gallery before it travelled to Melbourne. Brett knew that Vincent had a kind of perception of energy. Brett thought like Einstein as he painted *The Starry Night*. That pulsing seer that Vincent was, you know. But once he gave up the church, what was he? He gave away the poor downtrodden and got into energy. What a difference! Brett's pulsing trees follow a tradition that Vincent himself always used. I'm so bored with

landscape painting these days—like fucking quilts, they are.'

I ask Wendy about Whiteley's most ambitious works— *The American Dream*, which he painted before he left New York, and *Alchemy*, the huge work he started a few years later and never really finished.

Wendy reminds me, 'In the 60s people said, "What is the art that painters can still tackle?" Norman Mailer was commenting through his work on the riots in Harlem, the bussing riots, the white-only riots. People were re-seeking a way for painters to make use of actual life.

'*Alchemy* and *The American Dream* were taking on political themes. Brett had strictly opposing views, both in politics and his feelings about things, and Lloyd, his dealer, had been very supportive. Parties were given for him at the Chelsea Hotel on the rooftops. The conservative ones used to come and peer at him, and he said to them in his mind something like, "Right, I've had a successful exhibition that's fairly conservative. Now look at what I can really do."

'He was talking to every famous artist in the world and mixing with celebrities all the time. Hobnobbing with poets like Allen Ginsberg and Gregory Corso and Lawrence Ferlinghetti. We met Ginsberg in London, and he was very persuasive. The Beat poets had a bit of a hold over Brett. He starting reading Rimbaud, too, and thought he was thinking like him.'

That made me remember the story about Whiteley turning up drunk at a poetry reading in Sydney in the early 1970s. It was somewhere at a disused Customs office, and the

famous American Beats were to read from their work. He sat up the back on a suffocatingly humid evening, appalled that the so-called electrifyingly brilliantly erotically-everything poets were just drearily chanting and playing the squeezebox in gloomy tribute to Indian mysticism. Incense was wafting away, and so were the drongo poets.

'You boring fucking cunts,' he screamed. 'You absolutely appalling idiots! You're all charlatans, do you hear me?' In the end, the harbour-front police chased him into a gents' toilet, where they held his head in the lavatory by the hair and flushed it several times to cool him down.

Whiteley painted *The American Dream* in a massive out-pouring of energy, but he didn't get the response he was hoping for.

'*The American Dream* and *Alchemy*—Brett said he never wanted to get back into that state again. In 1969, in the States, his dealer declined to show *The American Dream* in New York. But that's where it was for, this colossal migraine picture. It had everything, you know. It was anti-Vietnam, anti-racism. It's a work the size of a warehouse. He used to often collapse in front of it, hitting the bottle to keep up the energy required to do it.'

'What was the fate of *The American Dream*?'

'It was crated and sent back to Australia. It was a black beast, in a way. The picture took nine to ten months. He was in this room painting it all the time, pleading with it to be fin-ished. Drinking his brains out. Sleeping next to it. He honestly believed he could change America's opinions about racism and

Vietnam. He thought he could do all that with this one big picture. I feared for him when he was doing it. And I had to break into the New York studio to make him rest. In a way, he was never the same after that. It took so much out of him.'

The effort left him exhausted and utterly disillusioned.

Wendy says: 'He had to get out. Away from it, away from everything. So he stuck a pin in a map of the world, threw the pin into Fiji. We turned up in Fiji, but he got into trouble with a drug bust that was blown out of all proportion. There was all this unbelievable fuss.'

She is really blowing up now, like a rocket-booster. Wringing her hands and sizzling the bacon and toasting the toast in the sunny kitchen.

I ask her, 'Do you really think you can meditate and take heroin at the same time?'

'Well, heroin was one of the only things that could slow him down, so he used to, I suppose, shoot up and meditate during his Chinese Zen Buddhist period. It was prayerful; it was his way to get quiet. So I suppose it worked for him OK.'

All around are quaint, mystical Chinese Zen brush black stick-ink paintings by Brett that are absolutely heavenly in their dexterity and charming unfussedness. Grinning monks and laughing mystics in brush swirls of robes, all swished onto rice paper in a masterly split second. Good to see them again. Like old friends.

'He loved that book that was all the rage forty years ago called *Zen And the Art of Motorcycle Maintenance*. He really believed

that as an artist you only get one chance to get it right.'

She delicately plonks down a dish of superb sizzling bacon and eggs on toast, and we sip percolated coffee. Scrumptious. So friendly.

So: he believed in the perfectionism of spontaneity and you only have one chance to get it right. That doesn't only mean drawing, but anything in life. I ask Wendy again if you can really meditate on heroin. Aren't they opposites? The physical peace of Zen Buddhism as against the chemical peace of smack?

'He didn't go through any one particular ritual to get ready for anything in his whole life. Ravi Shankar tried to explain this to George Harrison with a sitar. You just play that great music once, one chance is all you get. Are you asking me if he was peaceful when he was working? Well, he was when he wasn't bolting from anything he didn't feel like challenging. He had no tolerance for boredom, and he'd ask very direct questions. He could be very direct and very rude. Someone at a party would be making a point and he'd just get up and leave.'

Whiteley was renowned for his fights with art critics, in particular. Perhaps they helped push him over the edge. Unfavourable reviews of his paintings by the *Sydney Morning Herald* art critic Terrence Maloon culminated in a real war between the two men.

'Can you tell me anything about Terrence Maloon's critiques of Brett's work and how Brett reacted to them?' I ask.

Wendy cocks an eye and plays the actor as she paraphrases Maloon's remarks.

'"Let's look at why the work is famous," says Maloon. "The public perception of Brett Whiteley's work is fraudulent." Brett felt rage understandably, and he just did a bit of graffiti somewhere. He told the public that Terry had AIDS.' She laughs. 'Of course, he didn't.'

Remembering Whiteley's other marathon painting, *Alchemy*, she says, '*Alchemy* was painted when everything was much simpler, or sort of simpler. I remember Brett saying once, "To paint *Alchemy* I'm just going to have to remind myself that I'm not necessarily drunk or drugged."'

For some reason I start thinking about landscape painting in the classical sense of the word. So I quote from the master Corot, who said, 'There's nothing so pleasant as painting in the countryside.'

'Did Brett feel that way about his own landscape painting?' I ask Wendy.

She snorts by way of scoff.

'No, he was nothing like that! So many bloody flies, fuckin' canvas flapping everywhere. "Everybody knows I can paint that bloody wren!" He was always collaging things over themselves. He needed the studio with all his junk in it. Scissors, string, chalk, sandpaper, all sorts of glues, cement and hundreds of cans of paint, bottles of booze and you-know-what. He was fascinated with power.'

'Whose power exactly?'

'He was fascinated with all kinds of power. Vincent van Gogh's, Stalin's, the Kremlin's, the USA's … his power.'

'Was he capable of laughing at himself?'

She suddenly looks as if she misses him, and there's a slight smile.

'Yes, he could laugh at himself, and he was childish rather than child-like. Linear, he was. He had to be an Aries, a cardinal fire sign. Growing up in Sydney, white-faced, red-haired, so he was called "Bluey". His hair he identified with. He was jealous that I didn't have to get made up. He used to say, "All you have to do is sit there. I have to work hard to look beautiful." Going to Europe polished up his manners a bit. The look of him charmed people a bit.'

But Whiteley on the booze could be anything but charming, as many of his fellow artists found out. Wendy tells me more about Brett and booze. 'Brett was a binge drinker. He drank a lot of beer, and sometimes a great deal of wine. Drink is dualist—great to get pissed with a group of friends. He was running around town a lot.'

'Did he sleep?'

'Oh, yes, he slept. You don't on heroin. I've got up in the night to drink with him, keep him company. Sometimes he'd just sit at the kitchen table, so still and yet restless. He started to question family life and question his own addiction.'

'Did he ever draw out in the kitchen?'

'Drawing is addictive too. When we'd go to a restaurant, he'd be incredibly touchy—one second laughing and screaming, next second bored stupid and insulting some per-fectly innocent person. He's just leap up and go somewhere

else. And someone would say, "Fuck, Brett, we don't want to go anywhere else!" He drank, then he'd drive on the wrong side of the road when it was raining and go straight to a dealer's. He did this all the time.'

I remark on the fact that she's managed to kick the habit.

'I make sure I don't have drugs,' she says, 'because I don't want them. Some days are just bad days, that's all, like a bad hair day.'

She's high all right, but naturally.

'You've saved yourself. You've got through it all. Why couldn't he?'

Instead of balking, she answers immediately, clenching her fists, 'He couldn't conquer his addiction. He completely misunderstood his addiction—completely underestimated the power of his addiction. He thought he could conquer it, but of course it conquered him instead, and he simply couldn't stop. At that motel where he died, do you know they wanted to sell tickets to the room he died in, like they did with Princess Diana? Anyway, nothing surprises me now.'

'What did the motel room look like?'

She laughs sarcastically and says, 'Well, it looked like a treatment centre. Embolism he had, died of embolism, that's the truth. There were rumours that a dealer could have taken a last hit to the hotel and it was too good. He'd left instructions at the desk for all incoming calls to be diverted. The cops arrived here to tell me. Then one's worst fears … that the drugs were much more in control than I thought.

'Was he an alcoholic also?'

'Well, he never thought of himself as an alcoholic. But, as I say, he'd drink-drive to the dealers.'

She sighs and leans on her hands. That's another slice of agony over, but it's a sparkling blue day on the Harbour. She changes the topic suddenly.

'Arkie's engaged. We're having the wedding in April in our garden. We'll probably have to dig up Brett's ashes so he can give her away, put the ashes on a cut-out of him. Yeah, she's really happy. She's thirty-six now. Imagine a baby coming, how beautiful that will be. Now here comes your ferry. We'll talk again soon. You'd better run for it or you'll miss it.'

I wait on the wharf for Hegarty's ferry to chug back to Circular Quay. Accountants nibble sandwiches on the rockery on the sea-wall. Luna Park looms comically next door. I remember what Wendy said when I asked whether Arkie liked to draw.

'Oh yes,' she said. 'She enjoyed drawing, she really did. But Brett never encouraged her with her drawing because it would be opposition. He firmly believed that women should peel the spuds and do the housework and know their place.'

Her words swim alongside the ferry as I float back to the city.

The American Dream or The Nightmare of Rejection

Often a visitor to the States, Brett Whiteley, wife, babe, turn up in The Big Apple in 1968 on a Harkness Travel Scholarship. He

begins work immediately, using Marcelle Duchamp-esque bits of fur besprinkled with rice as dead-set modern art, coupled with ornamentation, ostentation, an observer through the pages of *Time* Magazine (his New Testament) of the atrocities on tap in Vietnam and Cambodia. He gets to and starts an immense work, *The American Dream*, which comprises eighteen 1.8 metre by 1.2 metre panels: large as a circus, were it flattened out. He requires 'America to own up, analyse and straighten out the immense and immediately seeable madness that seemed to run through most facets of American life — of little use of continuing. There appeared in such behaviour a stark sort of unnecessary cerebral violence, to which I was completely unaccustomed and of which I was in considerable fear'.

Employing lambswool rollers, car enamel, felt pens, fibreglass particles, stuffed bird as well as chronic inhaling of full-strength Marlboro cigarettes and tons of drink, he grotesqued and scissored out of *Time* magazine great lunar lines of bodies adrift in weightless time, birds stuck in recessed nests, keyboards glued also into recessed panels, glued on nudes, stuck on brains and twigs and so on.

Looked at coolly today it is ridiculous and no wonder he couldn't sell the thing or show it in America. He flies to Fiji and there, rests, turning into Gauguin, why not? Suva and marijuana are his new guidelines. *The Most Beautiful Mountain*, achieved in 1969, depicts lovely emerald hills and roly-poly paths and birds and eggs and glued-on diary extracts, but the

balance is perfectly beautiful again. *The Pink Heron*, in 1970, is like a rejected cupboard from a poorly done sideshow at a tawdry state fair. When we get into the early 70s with crapulous drawings such as *Self Portrait After Looking at Leonardo*, the game is just about up. He tunes only into himself and right up the arse of narcissism. He shows at Bonython Galleries but deals in deafening sound as well as imagery, using multi tracked tedious overproduced cacophony of recorded birds to yabber through any chance of conversation. No one says a thing as they're all deaf. But buying. As usual, he has overwhelmed the trendies. Had them bluffed.

6

I take a bus to Taylor Square, where I prop on a stone step in an ancient doorway and sense entire generations of poor junkies who've squatted there in dirty shorts and torn T-shirts before me. They've all been here, right where I'm sitting—all the poor shit-kicker junkies, sharing needles without a qualm, shooting up with strangers, sullenly trying to get ahead of the game on filthy Commercial Bank doorsteps in Oxford Street, while beautiful school kids run by, laughing and calling out to their mates: 'C'mon, you'll miss the bus.' I watch a junkie in a shop trying to offload a bottle of Seagram's London Gin that he's filled up with tap water. Strangely, the shop attendant doesn't seem interested in the deal.

I take the bus to Bellevue Hill, where I'm seeing Martin Sharp at his home—a mansion really. I get off a few stops early to take in the feeling of the neighbourhood. It's a refreshing walk—lots of birds singing, and frangipanis everywhere. I catch glimpses of sparkling blue water through people's back yards.

sharp and fuzzy

Martin's place is an enormous stone monolith, with huge wrought-iron gates that slide open for the visitor. Martin answers the front door wearing a braided kimono. He has an aristocratic, Oriental bearing and speaks in a croaky, quiet voice—a voice that's welcoming but world-weary. Very softly spoken.

He is surrounded by beautiful young men and women who help him complete various paintings. He's covered the walls with the original panels for antique comic strips and old posters. There's an enormous painting with 'Eternity' painted across it. The paint in Eternity is thickly sculptured, and I strain to see how he's done it. 'You'll wear that out,' he says with a smile, catching me staring at the painting.

As he fries duck for us both, he puts on a tape that he made on the day of Brett Whiteley's death in June 1992. Two talk-back cretins are laughing about the tragedy. The first one screams, 'How do you top yourself?' The other one says, 'Yes, how do you live with that kind of stress?' Then they start talking about Boris Yeltsin.

Martin's place has everything you can name in art or the graces of humanity. You rather expect Botticelli to rap on the portals and deliver an angel or three to be painted forthwith.

First we enjoy the duck. Then, thinking fowl, I ask Martin whether Whiteley's friends received birdly visitations after his death. He bites into a salt-encrusted wing and admits 'Oh, yes, a whole lot of people had birdly visitations. I mean, he painted himself as a bird, didn't he? On the way to the funeral there were all these birds, you see, all these beautiful, sudden, swooping Whiteley birds, showing us the way to the funeral.' He tapers off.

'People had all these birdly experiences when Brett died—seeing birds zipping through their windows in long lines! As the coffin was lowered into the ground, I saw lots of crows flock. The cemetery was the northern suburbs one—you never see a flock of crows there.

'It was a funny scene, it really was, and the funeral was low and quiet.'

'How did you feel?' I ask.

'I felt … I felt … I don't know how I felt. In a way I still don't know how I feel. I suppose I still expect to see him.

Then he's back to the birds. 'A bit after the funeral I was with Graeme Blundell and Margot Hilton and we were visiting Robert Adamson when a spoonbill landed right in front of Adamson's house. After the funeral I looked out the window one night, and what did I see? Two night ibises just flew by. You *never* see that. Yeah, that really got to me—all these birdly visitations.'

He pours me some tea from an ancient Chinese dragon-shaped metal teapot half a metre high at least. With his long silver hair, craggy, affable visage and fried duck, he seems like a noble lord full of kindness and patience, the essence of *noblesse oblige*. The kitchen is festive, illuminated by boisterous chuckling, a pot of stoical duck, fresh boiled eggs bubbling and rock salt in tiny, unusual pots. Martin's dog, Smudge, coughs politely behind his front paw as Martin puts on an another cassette tape of rapid-fire radio tributes to Brett. I hear Stuart Purves speak eloquently about the waste and pity. Then Martin escorts me into a courtyard, where he smokes and sips black coffee mysteriously and talks whisper-like of the days when he first met his old companion.

In the 1970s there was a visionary home for Sydney artists called the Yellow House. It was in Potts Point, down the hill from the Macleay Street fountain. 'What was it like there?' I ask him.

He rubs his chin thoughtfully. 'Well, it was all pretty trying—living and painting all together in the same bizarre venue—but it was good for a time. It was a big three-storey terrace house at 59 Macleay Street. I got it going. It was the old Clunes Gallery beforehand. I brought two shows out from London. So many people coming over to help get it going.'

'Your particular philosophy, what was that exactly?'

'We really just exploded there, I suppose—you know, exploded with original ideas.'

As Martin Sharp talks I can almost smell the marijuana

and turps and arguments that never stop. Figures wandering around from one room to another in the night, like ghosts. It occurs to me that I've lived in places like the Yellow House all my life, and they're always stuffed full of male artistic paranoia at some awkward hour. Hurt feelings on tap.

Martin is still reminiscing. 'People wandering around correcting one another's collages. Cutting up art books. Gluing pictures of things to other things. Devoting an entire evening to gazing at Cézanne's beautiful plates of fresh fruit standing in a cornfield—you know, that sort of stuff.

'Brett didn't live at the Yellow House. He just came there sometimes. He liked a beer—he drank a lot of beer. But I didn't enjoy drink. I never drank—some sort of allergy.'

Then he jumps to this: 'I remember Brett's language, because it's so incredibly unforgettable: his sentences, the way he ran them into one another—like cutting up glossy coloured pictures out of *Time* magazine or the *Women's Weekly*. He spoke in a new way. God, I miss that.'

I can see Martin's moved on from the Yellow House in his thoughts and I ask him how Whiteley looked in the last part of his life. 'The last time I saw him he was very lined around the eyes, and looking very washed out. He looked very soft, frail— very worn. I said to him, "You've got to be careful, because you'll be more dead than alive the way you're going." That wasn't long before the end.

'One day he turned up about midday. He was on the smicky-smack. Strange that he turned to me. It was a horrifying

day—this whole day was purest horror in a way you cannot possibly imagine. An Asian girl was living here,'—he gestures to the house we're sitting in right now—'helping out and so on, and then this boyfriend of hers sets fire to my home, you see. And what happened was, Brett just came in, dropped over or whatever. The girl's boyfriend hit her on the head and poured petrol around, then he set my place on fire. He got into the room just below here, in my studio, which is just below down there.'

It's hard to believe that this cascade of events being chronicled all fell on the same day.

'The girl was in fear of her life,' he continues. 'The boyfriend had all his hair burnt from his face. He was all in blue and looked like a big bald bikie, like some guy who'd picked her up at a club.

'Brett was pretty out of it—and he looked pretty out of it, just standing there, you know. Brett was in the fire, and he said—as this fire came out of my living room, he said—in that real quiet voice of his, "I dreamt the Devil said to me, 'If you're kind to anyone, I shall kill you'."

'A few days after that, Brett was out motoring in Frenchs Forest. It was very windy, and a lady in a smart sports car had a bit of tree fly up onto her windscreen. Brett stopped and picked up that log for her. He was kind. And that's why he died.'

'Did he have a premonition about his death?' I ask.

'Quite possibly,' Martin says.

'Wendy tried really hard to get him off the heroin in India—they met up in India, you know; in India they had another shot at being together … I'll just go and get another cigarette. Be right back. I've got a bit of a cigarette habit.'

As he comes back again he tosses Smudge a large wedge of fried duck. The dog groans with pleasure. It could easily be 1965 here. Martin's put on a Bob Dylan record—*The Times They Are A-Changin'*—and he's turned it up full belt. There's a cat sunning itself. One of Martin's artist assistants is painting a beautiful picture.

'They'd had a lot of fighting, really bad fighting. And they were having the Grand Meeting in India. Like it's their second honeymoon, like it's their second chance. And it was agreed they'd meet clean.'

He shields the sun from his eyes. Smudge is just about unconscious from the duck.

'She could see in one glance he was out of it. That was a defining moment in their split. She was so disappointed in him.'

I ask him about Whiteley's affairs with other women. I've often heard it said that Whiteley believed he could have anyone he liked.

'Public acclaim can be so dangerous,' Martin says. 'His mother didn't help much. She told him in front of Wendy, "There's nothing wrong with having a harem."'

A beautiful woman who looks just like a young Lauren Bacall calls out to Martin, 'Peter is still here, Martin. He's been

here all day to see you. Will I tell him to wait?'

Martin looks at me and says, 'Now hang on just a second, there's a street man I want you to meet. I'm sure you'll find him fascinating.'

Martin ushers me into another courtyard, which has a concrete and marble table set in it. But the seats are deck chairs with ghostly collapsed bottoms.

'This is Peter,' Martin says matter-of-factly. And in a whispered aside to me he adds, '*He's very different!*'

I shake hands with the strangest looking man I've ever seen. It's like shaking hands with a wet sock. He is attired in a blue-and-white NASA space costume with tiny rust spots on it and lots of curious little studs and zips and embroidered patches on the sleeves. There's what looks like a ripcord hanging out of the shoulder, and I'm convinced that if I pulled it smartly he would inflate. I really want to pull it but I fight off the inclination.

He is like a white pancake with caster sugar patted on it, but that's just the dandruff cascading out of his mushroom-like head. He keeps working his enormous hands together and makes a sibilant drooling sound. I peer into his spectral, pale-blue, slightly square eyes. Like little televisions, they are. As if lots of men have hit him as soon as they met him.

For a while Martin converses with this spook whom he's befriended. Peter seems to be giving Martin roving reports on the world outside. Then Martin gets up and goes to the kitchen, leaving me alone with this strange person. It's sort of

cold outside, and Peter keeps rubbing his long spindly hands together. I just don't know how to start a conversation with someone like him. He's not really threatening—just very, very strange.

'Where do you live?' I politely enquire.

It seems an age before he answers. Then, in a strange hush, he says, 'I live with a man who's a murderer.'

'Is that right?' I hear myself say.

'Yes, oh yes—he murdered six people. But he says he didn't do it himself. He puts the blame on Satan. It wasn't his anima who did it, but his soul possessed by the devil.'

'And what's he like to live with?' I ask.

To which he replies, 'How would I know? He's gay.'

This is the most unnerving conversation I've ever endured. Martin is still in the kitchen, and people keep going through the house carting large banners and paintings. A lot of people in the house, now, and a lot of talk is coming from it.

Peter is still staring at me with his TV-screen eyes. He continues his tale conspiratorially, like a mad magistrate whispering to the clerk of courts, leaning forward on his crooked arms to emphasise the drama.

I know Martin believes in demons and so did Whiteley, and I've known a few demons myself, but only in the past. I feel funny in the guts. Who is this mysterious person? I'm starting to feel hysterical.

'His reward is $100,000—make that $200,000. He calls himself Marilyn Manson these days, and he's on the run.'

That's it! I've got to get out of here right now. I can't wait for Martin to come out of the house. There's too much heavy stuff here, and I need time to sift through it. I almost run through the front gate looking for a city bus, or a Bondi one. It's a tremendous relief to be on the footpath. It's beautiful outside; though it's six o'clock, there are sunbeams everywhere. It's so good to run into the relief of the real world. Just the familiar sight of grammar-school boys and pampered schoolgirls—oh, let them be pampered! You don't want them to run into people like Peter.

In one of his poems T. S. Eliot used the sentence 'In short, I was afraid.' Did Brett Whiteley mix with people like him? Did he trust him, love him for taking him so far away from everything recognisable, everything comforting, like going to bed and going to sleep? Possibly I was meant to have this terrifying experience in order to comprehend Brett's last supper days when he was surrounded by weird ones.

I'm in George Street now, with kids on skateboards flying down the Town Hall steps and Pink Floyd's *The Wall* blaring from their portable hi-fis at full volume. It's mayhem. There are junkies everywhere, almost like it's some contagion. I go past an amusement parlour where a drunk is vomiting over a pinball machine. It feels like the end of the world here.

I'm desperate to see a movie, to get my tired mind off all the things I've been seeing and hearing. But I'm in such a state that I can't even order a cinema ticket. I thought going to the movies would be peaceful, but here it just means more

chaos. I want to go home to Melbourne, but St Leonards will have to do. I catch the train back to Keith's place.

The arrival platform at St Leonards railway station is incredibly bright, but every street beyond is pitch-black. I instantly get lost—really lost. The only thing I know is that I need to look for the big lit-up television tower at Willoughby, which is the next suburb to Naremburn—where the Loobys live, thank God!

Every street I go down is a wrong turning, and people are mean to me. I ask a policeman where Naremburn is, and he tells me to get fucked. I walk past lots of dark houses and find myself near Channel Nine in Willoughby, smelling marijuana everywhere, like the budding blossoms of springtime. At one point I think I see the devil, but it's just a sheepskin on a clothesline, with pegs sticking up like horns. I suppose I'm just freaking out.

I've been walking for some time up steep hills and under filthy viaducts, and now I'm looking at a concrete over-pass across a creek. There's freshly sprayed black graffiti on it. It says 'Marilyn Manson was here', and it includes three sixes, whatever that means satanically.

Now I know where I am. I walked right here last night with Keith to go and get our fish and chips, but that satanic graffiti wasn't there then. It has to be the murderer at large. Who else could it be? I start to think that I'm next—I'm going to be the seventh sacrifice. Did Peter say he was a cannibal? I'm not sure. It was hard to concentrate on what he was saying to

me, and he could have been joking. Surely he was joking ...

At last I bump into Keith, who's on his way back from his usual seven-mile walk to the bottle-shop to buy more grog and cigarette papers. I'm absurdly glad to see him, and I make sure I tell him so. He's bought dinner too, so we go home to April and to Ric Abel, where we share another meal in the comfort of each other's company.

7

Back in Melbourne, I bump into Nick Lyon, who had a long friendship with the Whiteleys. We first met at a wake for Adrian Rawlins, a deceased bohemian bard who was a great organiser of disorganised pub poetry readings. I seem to remember owing Nick ten bucks from some night in 1970 at the Albion Hotel, so I buy him a drink. When I tell him I'm working on a book on Whiteley, he says, 'I played the fiddle for him thirty years ago. They were lovers then—*the* lovers. Bohemian prince and princess. We should talk.'

It's early the next day when Nick rings me and tells me to come and see him immediately, while everything is still in his mind. I get the tram to his place in Northcote.

Nick Lyon resembles a kind of suburban aristocrat himself, guru-like and round-shouldered. He sweeps me into his kitchen, which is full of an eclectic array of paintings. Although it's mid-afternoon, he's preparing an elegant breakfast of poached eggs with lashings of cracked pepper.

is excess enough?

He speaks with a slightly English accent, coming from Lancashire as he does, and starts talking about Whiteley and his dogs.

'He had two silky terriers called Sense and Reason, and another dog he called Boogier, like Booger-ya. This last one was a stray black-and-white, and its eyes used to say "I know exactly what you mean, man."'

He laughs. I do too.

'He always had the dogs at his heels. We used to go to Mount Wilson at the north end of the Blue Mountains—Peter Kingston, Brett and Wendy, and Arkie and me. This was around 1980. The dogs would get into the Mini Moke and off we'd go. We went to a place called Apple Cottage, and Kingo made a movie called *Brett and Butter (Productions)*. It was Kingo exploring experimental film-making.

'I was very fond of Mount Wilson; I went there for the mist—and the colours. It's really amazing up there—amazing European trees in autumn. The

camera was hand-held, and we had lots of shots of the little black-and-white dog bobbing up and down, running through that mist ahead of the car.'

He starts ruminating about Whiteley. 'There was real feminine side to him. Greg Weight gave me this photographic portrait of him.' Nick starts rummaging through a bag of photographs and folders, appropriately filed behind the fridge. 'I've got him here somewhere. Where are you, Whiteley?'

He finds it and presents me with a photo of a very effeminate-looking Whiteley in a woman's top, presenting himself as the perfect New Man for the early 1970s, suave and sensitive-looking, like quivering litmus paper.

'It was like a singlet—a chemise. It was Wendy's, but Brett loved wearing it—loved the feel of it.

'That's what really mystifies me about Whiteley: I don't know why he had to do those things to himself all the time. I mean, he always had to be up. Maybe he got depressed—but what's wrong with occasionally being depressed?

'Here's a tale Brett once told me. Some time in the 1980s, he was up at Carcoar on a dirt road somewhere, and he'd taken a tape recorder with him. He got out of the car and saw this guy just walking over the hill. This guy looked mad but interesting. Brett put the tape on him and the poor guy talked all day into it. When he played it to me later, it was two hours of gibberish.'

He finishes his breakfast, pulls the cork out of the claret bottle and pours himself a glass.

'Whiteley said to me, "It sounds like the Bible in a twenty-minute burst, doesn't it?" The guy had done a forty-day retreat—forty days and forty nights without speech! It was like meeting Moses. After a lot of silence, your mouth muscles go funny, and it's hard to talk.

'I saw Lavender Bay in its early days. It was a very pleasant harbour-side residence, and a fairly odd-angled building. I was living right around the corner from Brett and Wendy, so I was always going there. This is 1972 or so—I saw their home before it got done up. I just used to walk around there with the violin. At that time I was studying at the Con.'

He sips his grog thoughtfully.

'Brett ran his home as a king might run his court. It was like a fiefdom he invented. He told me once that his eyes were too beautiful to read with; it would be a waste to wear them out that way. So he hired people to read and play music to him while he painted.

'Brett got me on to Van Morrison's *Astral Weeks*,' Nick says. 'So I improvised from Dylan and Van Morrison, and I played sitar for Whiteley at his studio, the Gasworks at Waverton.'

'I used to love to play around there. There was always some sort of action, and a lot of fun. Brett made me happy. He was fit and full of go, and he introduced me to Van Morrison's *Astral Weeks* and Bob Dylan. I played my own music, but I sometimes used to play along with the Dylan songs while he painted. That would be a sort of Friday-night thing—any time, really. I

was a free squire, in a sense. Their place was extremely inter-esting and friendly.

'In the morning we'd all go to Paddy's Market in Chinatown from his tower. We'd end up at the Tai Ping restau-rant. If Asher Bilu or Tony Woods came to town, we'd blitz the Chinese food. Brett would order the prawn dumplings, and it'd be a beggar's banquet pretty soon. It was always like a little entourage, and Michael, the proprietor, made it a home away from home. Brett used to shout a lot of the dinners. He's be so happy he'd get up and dance.'

Nick tells me Whiteley looked like Isadora Duncan when he danced.

'One day we went to Epping to pick up a bonsai tree for the Yellow House. This was nine in the morning, and all these schoolgirls were wandering around in their tartan tunics. Brett's in all this white flouncy stuff, like cheesecloth, sitting in the white Moke, and the dogs are going yah yah yah.'

He's rocking around on his haunches, reliving it.

'Brett went straight up to this really young schoolgirl and looked her straight in the eyes and said, "What's the news?" Just like that. Can you imagine the effect on a little kid like that? From her young eyes, how that would have presented itself? Just looking at him, with his great big bush of red hair and metres of muslin!

'One of the first times I played violin for him, Arkie was running around naked, screaming and laughing, and every-thing was really loud. Brett liked whisky then. There was always

lots of whisky. We'd just relax together—he really turned me on. He got a lot of artists to do their own versions of a bonsai tree, and that was filmed by Kingo and Aggie Reed and Albie Thoms.'

I notice, above the kitchen sink, a portrait of Nick which looks remarkably like his guru. He tells me it was done by his girlfriend, Julie de Lorenzo. Now he's talking of shocks—big ones—and his eyes are wider somehow.

'You had to watch out going upstairs at the Whiteleys', particularly if they were fighting. You didn't want to interrupt them if they were preparing to shoot up on the bed together. At the Circular Quay studio, he had five TV sets all joined together—all channels on at once. He had a little keyboard, and used to doodle with one finger. He had an amazing desire to be a muso, but he'd just dance around the keyboard.

'He always had a sharp eye for something he could get away with. We used to go to Luna Park a lot, because it was right next to his home. He'd reach out and pull a piece of scenery painting off the Tumbling House and stick it onto one of his own works later on. Anything he liked—in the pocket it went.'

I ask, 'Where did get his power from?'

Nick punches the table with his huge fist. 'He was a fucking Aries—all Aries are like that, man. You better believe it! I remember he drew an old man in front of me at Lavender Bay. This old Italian Michelangelo-looking man just spun out of the paper. He drew it real tight, right in front of me. It wasn't like his usual drawings—it was classical and wonderful. He was

fantastic with colour, creating ochre-y trees with real birds' nests in them. We did a lot of quiet time together too. You know—well fed, relaxed, not speeding around, not drinking. In neutral.

'I was always welcome. "Hi, mate! Have you got your violin?" His topics of conversation really jumped the track all the time. Yeah, he'd just crank up one subject and the whole talk would go bang! There was a lot of jester in him.'

'Did you ever see him asleep?' I ask.

'Yes, he looked like four o'clock in the morning—just sleeping on a chaise with his shoes still on. Like he sprang into sleep to surprise it.

'Last time I saw him was up at Palm Beach, getting ready for a party—drug dealers. Jack Thompson was up there, and so was Janice. Brett and Janice arrived both in black—I mean completely in black. Very subdued and very white in the face, sort of coy. I could sense a coldness, a real coldness—like OK, we're movie stars, OK? They came to the party and we had a band there. They were in an altered state. They disappeared for twenty minutes. This is a totally different character that he became, and I couldn't talk to him when he was like that—no one could.'

He puts the kettle on and makes Chinese tea. He's relaxed but pensive.

'Do you remember Kym Bonython? I did the music for his openings at the Bonython Galleries. Whiteley used to walk around those opening-night shows checking out every single

crack and every single shadow with his arms in the air, and he's tuning, tuning, tuning—tuning the whole space to a point of perfection. And when he thought it was perfect he whistled like a whip-bird. He used to call out "Swacker!", which was supposed to sound like a whip-bird.'

The tea tastes good.

'The whole idea of man in nature was his obsession. He used to like caving, getting into nocturnal things—finding a nice secluded cave and meditating in a billabong. Just going away, painting.'

It's starting to get dark outside. There's no noise in here, just Nick's quiet smoking and surreptitious sips. He's elegant and charming without trying to be so. I suppose I like him because he's understated but very passionate. He never shouts, apart from when he uttered the word 'Aries!'

'Whiteley was just so speedy. I mean, we used to go to seven movies in a row on the same night or the same morning. Wendy would come too, and we'd all do a few movies together. Brett'd say something like "This is hopeless, this is boring" and then we'd go and look at something else that he'd pick out. Sometimes we'd only watch a couple of minutes of each film, each two-hour feature film, and then Brett would be tearing off to another one, with me running after him along the dark carpet of some overheated, suffocating cinema in Sydney. He got bored in a second, and you just had to go along with it.'

Nick sips the wine and the tea in equal dainty measure and savours a last cigarette.

'It all got too much—the heroin, I mean. One day I came in when Wendy and Brett were shooting up on the bed, and I thought to myself, it's time for me to go. I got the message. I didn't want to start too.

'I was really saddened when he died, I really was. He just blew up. There was karmic residue there, that's for sure. It's so sad, man. Just losing such a charismatic sensibility that was unique.'

As we shake hands at his door, Nick says Whiteley should be remembered for all of his qualities as well as his downfalls. Maybe he's the sinner in all of us. Maybe we have to understand ourselves to get onto him.

Just as I'm about to board the Northcote tram for home, I hear an incredibly beautiful voice. Someone's singing an aria in her home across the road from Nick's place. It makes me think of that old saying that art is for everyone: art is the servant of the people.

8

The voyaging and vanishing and upsetting and comforting (intellectually speaking) life of an interviewer can be as exciting as the spark of existence itself, in the search for utterance and collected shades of meaning. And in that fevered hunt for memorable recollection the interviewer can travel far and wide to seek a truth or an exaggeration that tints the dead-white cheeks with rouge to lend the subject life again.

The right words bring them back. Can you say them—think of them, write them? Yes, you can—if you're high.

I've been to Sydney twice now to learn more about Brett Whiteley and have enjoyed the bizarre hunt, but now good fortune turns up and my next witness to the life that was lent briefly to Whiteley lives just down the road from me and, it being a splendid September night, I stroll towards her cottage and tap lightly on her door.

Sally Lynch, I met over twenty years ago when she did the switchboard

when brett met janice

at the Pram Factory theatre in Carlton. An ex-junkie with an exceptionally good memory, she makes black coffee for me as I have a bit of a headache. Then, mysteriously, she tips the coffee into a light-green plastic thermos and screws the lid on tight. Why? History doesn't relate.

A train or two rattles past not far from Kensington railway station and her china collection tinkles as it does so. But then the vibrations steady and she leans sturdily on her left palm and remembers meeting Janice Spencer some years ago at Narcotics Anonymous. Janice is someone I want to know about, as her life with Brett after he split with Wendy is largely unknown. The fact of the matter is that they lived together for a long time and she looked after him in her fashion, got him off smack and got him back on it. And after he died she did too and I have a feeling she's to be pitied in the chronicle of his life.

'After Janice went to NA she had quite a few years of clean time. It must have been 1988 when he got with Janice, this sweet beautiful girl. They all said

"She's a real sweetie." Did I know her? Not really. She was like a younger and more beautiful Wendy. When I met her in Darlinghurst, at Ruby Rich House, she was quite gorgeous.'

Sally's trying to look as though she's relaxed; she isn't, not yet. She lights up another smoke and fiddles with the aluminium ashtray.

'She was sharing. Sharing means getting up for ten or so minutes and coming out and confessing your addiction, you know? Standing up the front and telling the truth without a qualm. It was in a community hall that I met her. Just a community centre it was, quite austere.'

With a huge drag on the cigarette, the ash curls and I keep wondering how it stays intact. Sally's smoking reminds me of the way Wendy smokes. Ex-junkies smoke with such gusto. It's as if the nicotine makes up for the smack if you smoke the living buggery out of it.

'There were a hundred people there easily, but she stood out. She was a nervy thing. Quite painstakingly groomed and at least a decade younger than Wendy. She probably got into drugs as a teenager. This was in late 1987, I think.'

Sally sips at a big beaker of something. She is seemingly calm now, although it's hard to say because she's pretty hard to read. She folds her arms defiantly and cranes forward almost as if to spit in my eye. Then she says this in an undertone.

'I spoke to her a few times. Anyone can go to these meetings, so long as they identify that they've got a real drug problem. Each meeting has a group and each lunch-time

people join this group and you learn to take a certain responsibility. Someone's got to turn up early to open up the hall. You've got the responsibility to handle and look after the keys to the hall. Have some coffee.'

She vigorously unscrews the thermos and pours me some rather penetrating coffee. Then she leans back with her cigarette, making sure the halo of smoke never goes near my face. Earlier she ticked me off for mocking junkies in the press. It's true, I *have* mocked them because I mock everything, including myself, because I happen to be a clown. She seems more animated now and much more alive: she's talking with her hands.

I ask her why she wanted to get off heroin. The heroin is a long time ago but she's not put out because she feels like telling the truth.

'I wanted to get off it because I was sick of hanging out with no resources. I felt like a *thing*. A nothing. I felt like a nothing, you know?'

I do.

'I was so completely and utterly shut down, quite suicidal, extremely depressed. I had a couple of people in my life. A long-term friend rang from Sydney and I just said I can't come to the phone. But I wasn't really going anywhere.'

More sips of friendly liquid, and she shakes her hair and rolls her eyes ever-upward.

'You'd better watch what you say about junkies. You don't know what they go through. I mean, look at how you used to drink. I used to see you positively shit-faced all the time

in Carlton; it's amazing you can still think. Junkies are very marginalised people, so you should show some sympathy.'

I just look at my shoes after being admonished. Sally suddenly looks forlorn at the sadness and the waste of those lost years.

'I was living in this refuge for homeless people when I met Janice at that open night and she talked about her coping skills. Afterwards I told her "I liked what you just said." She was growing up in public, but she seemed a bit princessy to me. Shy, she seemed, Janice. You know, a little bit shy. Naturally red curly hair, she was the kind who'd always have a girlfriend. At NA a lot of the girls go there for a girlfriend. She was always seen in all the coffee shops. Around about that time I saw Brett going out with her, and to me he looked like a silly old goat. A bit long in the tooth to be driving a sports car.'

She rolls her eyes as if to say "What could be more ridiculous?" But she herself drives a Merc.

'His sharing was bizarre. The meetings run for one and a half hours and normally each sharing goes for about ten minutes. You call for a couple of strong talkers to start it and to open it up for the shyer ones. When he first shared, it went for an hour and a half. Can you believe it! He said "I'm Brett, I'm an addict I'm (so many) days clean." You're not allowed to say your second name, of course, but we all knew who *he* was.

'He spoke for over an hour about how wonderful heroin was! It gave him the ability to be so creative. People laughed! And he assumed people were laughing with him; he

was incapable of seeing outside his situation. Was I laughing? I thought it was fuckin' tragic!'

She is so shocked, still, after all these years. She's never going to forget it, just how insensitive he was towards others, other junkies that is, impoverished junkies without sports cars or famous names. She resumes her composure, grits her teeth and drinks her fluid.

'He made these idiotic T-shirts, lots of them, and brought them to NA. They said, "Make 88 Straight". This was in 1988, the Bicentennial year, and he made these idiotic T-shirts with that printed on them. What you're supposed to do at these meetings is confess about being drug free, and he come comes in with his designer tracksuit on. You'd have to say he misread the whole thing.

'Another time, at Paddington NA a few years later, he'd relapsed.' She seems unpitying. 'In a private detox, he was. Someone had gone from the meeting and picked him up from it. He was quite desperate. He talked at the Paddington sharing in the old church hall. He talked about how unique he was! My boyfriend says Whiteley used to sell to support his own habit.'

She stares just about straight through me in an over-shocked manner, eyes bulging.

'He didn't have that earlier glow, and his face was quite devoid of life. And afterwards he botted a cigarette off me. I thought that was bizarre. Here is this man who is worth millions and he's botting a smoke from a copy typist on sixteen thousand a year.

'The next time I saw him, Janice was there. She was on his team, they were still connected and Janice was still gorgeous. He'd left Wendy. Janice and Brett lived somewhere else. At one stage Brett had a bodyguard, paid to keep him off drugs.

'I went to Wendy's one day with a neighbour who was also in NA, who was a friend of Wendy's. When we went there this day a cleaning lady was wiping down the benches and Wendy was talking to her, conversing with her like she was a paid friend. Wendy was depressed about the divorce settlement.'

This is lonely and sad stuff, all right, but I'm determined to hear the full bile—the bile, the whole bile, and nothing but the bile.

'She was waiting for a courier with a divorce document, and this document would tell her what paintings she could keep. At no stage did she ask me how I was going. She had lovely clothes on but was in a lot of mental pain. She was clean, had gotten clean, in NA. She did the North Shore meetings. Janice Spencer, she continued to stay clean. She was very much part of the Buttery Rehab out of Byron Bay. Brett had a house at Wattegos near there. I assume he took Janice up there—there's a big NA community there. Course, a lot of them fall by the wayside.'

It's getting late, and I have the impression that all the conversations and agonies of Sally's addict friends, and every single thing they've been through, are contained cocooned within this kitchen.

'A few years after Brett died, Janice did make a conscientious decision to drink and she became a social drinker. You

must talk to Michael Saker: he knew Brett really well. They were great friends near the end. He's a reformed addict, he's on methadone now.

'After Brett's death, the Whiteley family gave Janice one painting of him fucking her. That's all she ever got from them, with all their fucking millions. And it's unsellable. Why couldn't they have given her a measly two hundred and fifty thousand bucks so she could have bought a house. That's the least they could have done for her and she might still be alive.

'Why were they so mean to her? The divorce was signed, sealed, delivered. Brett and Wendy had split up and he'd got the next girlfriend. I think Janice was very distressed. She probably thought she'd get a significant bit out of it all, but she didn't get a single thing.'

I am glad to hear truth as it is spoken by someone who has truly nothing to lose. I walk back home, up our old road, and find my family sound asleep with the TV still on. As I prepare for sleep myself, I can't help feeling that it's good to be alive in such a horrifying world.

SOME MONTHS LATER, I speak by phone with Deborah Pearse, a close friend of Sally Lynch. I need the inner circle of the junkies to tell me more about Brett—and she fills me in on some aspects of Janice in relation to him.

'He was defiant with Janice, and generous to her as well. She really was his best treatment. She was the only one who could keep him off it. He fought her like a demon to get

it again but she kept him off it until they both went on it again.

'Wendy had a bit of power; Janice had to contend with that power. Janice was a very shy person. She appeared quite self-possessed but she was terribly shy of tough people. She would much rather withdraw than fight someone else, any time you care to mention.

'After Brett died she was just devastated. She really thought people knew just how much she meant to him. Brett used to say "Janice would be all right. She will always be taken care of", but she was not.

'She ought to have been given a medal for looking after him, in my opinion—for putting up with him. She loved him, she was emotionally blackmailed by him but never gave in to him. She was strong, so she kept him off heroin. They had a rare relationship.

'She picked up a drink four days after he died. She went to the funeral; it must've felt strange for her to do something like that and hard for her to do. I picked her up at the airport after the funeral: the airport's at Ballina. She was in bad shape. Couldn't have a shower, very worn down, she really loved him. And he really loved her. She never had the life again. He used to say of her "To me, she's my hope."

Eight years after he died she was still so miserable, it just destroyed her. She never got over him. Four days before she herself died she was so friendly still, but using Naltrexone, which keeps you off heroin. She was very unhappy. Janice believed that if you don't use, you will get yourself back

together. "I'll ring you when I get down to Sydney," she said to me. She died on the Wednesday. For three days she didn't take Naltrexone. If you don't use it for three days, then take heroin, you die.'

Phil Tory, who was close to Janice after Brett and before Janice's death, paints a similar picture of the pain of his late girl-friend:

'After he died she started on vodka. That was awful. She had to speak in the impending court case. It was real pressure for Janice to seek her entitlement, her rights. We had gone our separate ways by then. I think she went through an incredibly humiliating experience and in the end her claim was dismissed. It looked to me as if she was treated not much better than some part-time hooker who'd stumbled into Brett's path. She was so steadfast because what she had to continually deal with was his anger and resentment. She expected she would be taken care of by the settlement.

'I guess she wanted a certain claim to be honoured and she expected recognition; she got this other recognition. If it had been any other courthouse in the world her claim for com-pensation would have come through, because she really took care of him when no one else was capable of that kind of stuff.

'You imagine the will necessary to conquer his addic-tion. He was quite a handful, you know, but she managed it. The ultra-conservatives got what they wanted and all she got was a painting. I told her she wouldn't win on the merits of her case but she wouldn't or couldn't listen to me and went into it with

these lawyers. She liked Lucy Turnbull, for example—Malcolm's wife—as her solicitor. I wanted Minter Ellison, but of course Janice was determined to do it her way and all she got out of it was a painting.

'By nature, she was very on the moment and funny. There was a real lightness there, all right. She told me one night, when she and Brett were together, that Brett had had this struggle with heroin in the previous five countries they'd been to and had relapsed each time. And I thought "Wow! The power of her staunchness to keep him off it!" The patience she showed to deal with his addictiveness and the sheer strength of her positiveness was on her own head. She had overcome addiction at that stage. If you had these attributes you'd be just about perfect.

'It's good that you're doing an honest book about Brett and intend to include a decent story on poor Janice who came out of it so badly. Because the story's no good without poor Janice; she's the one to be pitied, not him.'

9

Whiteley had a nephew. He's forty-ish, looks just like his uncle though he's smaller and stockier, and he's very jumpy. He likes a drink, and he's always saying, 'I'm going to cut it out tomorrow.' He's very showy and, just like his uncle, completely charming—almost overwhelmingly so—and he has a roar for a laugh, an incredible roar that doesn't last long but is life giving.

He is Vivian Whiteley Hopkirk and I used to know him, and drink with him, years ago. But I didn't know he was Whiteley's nephew, even though he probably told me a hundred times when we were tanked. We're sitting at a tenth-rate Italian cafe in Lygon Street and it's very cold and depressing, with our idiotic butcher's paper serviettes flapping all the time.

Vivian's face is the colour of gun metal as he rolls a dreadfully hung-over cigarette and asks the waiter to get him a glass of white. Unbelievably the cask wine is three dollars twenty a squirt. Vivian tells me he's drunk, I tell him to eat the cheese I've bought. He cautiously nibbles his cigarette papers, but

just like his uncle

can't get the smoke to light.

'My mother is Frannie Hopkirk. That's right, she's Brett's sister. She wrote a book on him—a bestseller called Brett. She got a $30,000 dollar advance. She dedicated it to me because I'm the one who got her to write it—I held a gun to her head. The book saved her, absolutely: it's given her respect. Fuckin' oath she's a raconteur!'

Raucously Whiteley Hopkirk quaffs and scoffs and slakes the glass and suggests more, so I go and fetch him more.

'Brett used to call his sister "Benzedrine Beaver" because she was so speedy; she still is at sixty-seven. Her father Clem was divine, absolutely divine—you know, the perfect gent syndrome. He had a heart the size of a fucking tractor. The day he died my mother gave birth to my baby sister. Her middle name is Clemency—you know, mercy. Clem used to work in films in some way ... oh yeah, I remember: he was the head of Hoyt's in Australia.'

He mimes with his fingers on his lips an Errol Flynn moustache, and he grins at me rakishly and raffishly.

'He was the cravat itself, and his old cravat actually hangs in Brett's studio up above his bed. I lost my grandfather through a broken heart. The Whiteley women—there's nothing like them. Blanche D'Alpuget only lasted two days when she tried to write about Whiteley; she called it off, saying she didn't need the trouble.'

He swears, and indicates another el cheapo white, which I can just cover. He reluctantly eats some cheese and adjusts his faulty sunglasses. He's wearing a great deal of jewellery—gold—but the day is overcast, so gold isn't much use. Vivian chucks the white down so it doesn't touch the sides. He's really lit up now, spiritually and chemically. He's terrific, zesty company, and he leans forward on his muscular elbows conspiratorially.

'Brett was the funniest man I ever met in my entire life. He would easily eclipse Oscar Wilde. When he wasn't depressed he was always joking, and when he was going to crack a joke he would rub his palms together with glee. Brett was the most pleasant company I ever enjoyed and he had the most catchy laugh. His was a captivating laugh—it caught you, it went over to you and the force of it made you laugh as well. He always said you've got to look for the gold in things, meaning you look for the best in everything. He just loved everything he did and said. He didn't have a film of malevolence in him [although] he said about my mother Frannie "Just forget she's my sister, man."

'Wendy controlled all the finances. Wendy never liked my mother, for some reason. My mother would keep her starving kids locked outside if she needed to in order to assert her dominance.' He's starting to peck at the Jatz cackers, as if they are made of memories. He's incredibly athletic and flexes his muscles all the time. But he's terribly pleasant company and very affectionate, too.

'Brett had two little dogs, called Sense and Reason, and he absolutely loved them. He used to call them a cab and pay the cab driver to drive them around the Harbour for an hour. Because he feared for their boredom—that they might become bored by his conversation. And then, when they bounded in an hour later and jumped up on him, he'd say to them, "D'y'ava good trip?" He'd converse with the dogs for ages, completely wrapped in them, cocking his eyes at them, sort of wagging his ears at them. I said "Let's live in the south of France, Brett" and he said "We can't—I've got the dogs."

'He wouldn't kill a mosquito. Although he did want to kill a person once. I don't know if I should tell you this, but anyway it's a long time ago, and besides the bitch is dead. He told it to me like this: "I was coming down in the lift at the Chelsea Hotel and this black guy was standing there grinning at me, in this stuffy lift, in a defiant kind of way. He had killed a girl, this white chick, who used to fuck me. Apart from that, I never wanted to kill anyone." I was sixteen and I'd just come back from London, from seeing my mother, and that's why he told me that story.'

Brett's nephew looks downcast and temporarily mournful. Time for another white. In my hand I've got exactly three dollars twenty, so I get him a last drink. We're not exactly yuppies.

'So you want me to tell you a few things about him ... I know what you want: you want a picture of the normal man. But listen, he wasn't a normal man, and that's why everyone's obsessed with him. But no one's got him right. You will get him right, though. He sort of jumped at everything as if it wasn't going to be there in a second. He sort of changed time. What might have appeared swift to someone else was agonisingly slow to him. He sort of made time change him, he always described things as he did them. He was just so interesting.

'Once, he made breakfast for me—a long time ago, when I was just a teenager with him in Sydney. "Now listen man," he said, "this is how you cook toast. You don't just *toast* the fucking bread, man, you *sublimate* it. You sublimate it and bless it with avocado." When Brett made some coffee, he even made that exciting and dramatic. "Just watch this thing ejaculate, baby." All he's doing is percolating some coffee for his young awe-struck nephew.'

The waiter asks if we want more wine, and Vivian realises I'm skun. So we just sit there for a minute more without money for anything. He's so broke he hasn't got public transport money to get to his place but speaks instead of his real home in the south of France.

'It was Beryl [Brett's mother] that got Brett started in

London. She was incredibly well connected and put in a good word for him. Her contacts! Fuck, yeah!'

He's jumping from subject to subject, trying to give me an elaborate idea of Brett.

'Brett was a pyromaniac when he was young. He'd blow the shit out of letter boxes. He performed kidnappings upon poodles. When the newspaper ads came out with the portraits of the pups, these demented poodles, Brett would hand them back and cash in, big time. That's what he was like, that was a part of him.

'I'll tell you two things. In the old days Patrick White idolised Brett and Brett liked Patrick too, very much, mostly because he admired the novels and realised what a great artist Patrick White was. Patrick White and Brett walked their dogs together every morning at Centennial Park, so I mean they had to be close. But Patrick expected Brett to take a stand on nuclear war —you know, nuclear disarmament—and he expected Brett to get up on the podium with him and address vast congregations of protesters who were very passionate about the world not ending. I saw Brett that morning before the big meeting and he said to me, "I can't do that, man. I'm just a painter. I can't get up and talk about nuclear bombs." So I read a poem to him that I wrote about nuclear war and he said it was rubbish. That really hurt me.'

He looks down and savagely bites his lip. He's very bitter—understandably—and his voice is more penetrating. It's a privileged voice, not mellow or nasal—fairly quiet—but theatrical.

'Brett couldn't have lived in the south of France, you know, because he loved being recognised, being known. He was driven by the need to be noticed. He had to be saluted by anyone on the street—anyone would do, the merest stranger would do.

'I was seven when I first met him, when he flew to New Zealand. He was already famous, with a halo of fiery hair. I had four sisters and we were all living in New Zealand so that's where he had to come to see Mum—his sister—and us kids. For Brett Whiteley to fly to New Zealand, well, that in itself was an acid trip. What he did on that visit is so indelible in my memory of him. He made this amazing pirate's map, painted it on paper, put it in the oven to scorch so it looked at least two hundred years old. It was a totally CIA operation, painting that map, painting it secretly there for us to discover. He went to all that bother to make an authentic-looking old pirate treasure map. Do you know we Whiteleys go back to Daniel Defoe?

'Brett could be so incredibly loving and thoughtful. But he was jealous of me. When I was only twenty-two everyone was talking about me more than him. But he'd say to me, "Listen, there's only one artist in this family and that is me." Brett once paid me a lot of money to write special poems to describe the pictures he was painting at the time. It was commissioning money, you might say. But after I'd written these poems he told me they weren't good enough.

'Another time, he broke my heart clean in two. He cleaved it in two—yes, he did. I turned up at his studio and had

bought him his favourite flowers—blue ones (I can't think of their name now). Anyway, I handed them to him and said "Hi mate", and he took them and threw them away. That knocked me out, that he could do that.

'I remember being at his studio at Circular Quay once. He had this Japanese thing going. You know, painting as if he were Japanese. I suppose it's really offensive, pretending to be something else, I don't know. Anyway, when you went into the studio you had to be perfectly still and completely silent. And this time he was hissing at an imaginary hummingbird nipping at his canvas. He shooed it away, vigorously, although there was nothing there. There were lots of us there as he painted: he liked it that way. He was very Buddhist—very, very Buddhist. You can't say "Buddhist on fire", but that's how he was: just on fire all the time. He inhaled space.'

Yeah, I think to myself, that's it: go to Japan and draw like them, even if you can do that here at home, stoned, better than going there. Forget the visa and get stuck into the Indian ink and you'd draw ocean waves better in Australia than any practising or dead Zen master anywhere.

'I was with Arkie and Brett once and we went to Grace Bros, the big store in Sydney. And Arkie said, "Dad, you can't go in there with painted toenails. I'm embarrassed with your toe-nails painted like that." Then she said something he didn't like to someone, and he mimed a can of aerosol and made a hissing noise, a violent hissing noise as he sprayed his imaginary aerosol can around her ahead as if to spray out what she was

saying. "You can't talk to people like that," he said. He always had to come out on top. When we were all watching him painting in such reverence I said something, some philosophical comment, and he told me to shut up in front of everyone, and that hurt me too.

'Brett started seeing me again not long before he died. He said, "Vivvy, come to the studio, come to the studio and be with me." He wanted to do that fifty-panel painting, but he wanted to die too, he really did. He'd done everything and he'd done enough.

'I was in East Berlin when he died. I got a phone call from Paris and I just cried and cried all day. I couldn't see it coming, I really thought he'd live forever.'

The Australian Art Prize for Coming Out in 1976 & 77

Whiteley's *Self Portrait in the Studio* (1976) is a gimmick that's had its day, complete with adhered pubic/public hair, chocolate box-style self-portrait holding aloft a crudely rendered oval looking-glass painted on paintbrushes, homaged Matisse rugs, Bonsai'd ink leaves and a wonky nude lady cross-legged on a bed that's lifeless. The artist is narcissistically becalmed, all at sea within tributes to his own dextrous colossalness. It is him at his very gulley-trap worst, a ram jam big bam of self-loathing. Yet he wins the 1977 Archibald for this work.

Presumably it is because he won an Archibald for this large turkey that he lost the plot, knowing instinctively just

how bad a painting it was. His *Still Life Without Lemon* (1976) is a return and a reprieve; it is good to see confidence and virtuosities come full circle. He paints every hour, like Picasso, so some have to be good, and the lightning speed of brilliance and patience and impatience dance here to great charm and affection for all surfaces. Are the painted or photographed little oysters real? You really want to devour them, real or painted, and his old perfect taste is back to lofty heights again. He sure abused his good taste.

His favourite year was 1976 because the work of that time is so unevenly good. His *Magnolia* is brilliant and alive to the rendered fact of dexterous ripe pinky peaches and wonderful glossy crimson painted cherries. An adhered lemon you want to lick and exotic Magnolia petals that teach you love of painted leaves. The whole thing is really extravagant. In his notebook he says: 'Mine isn't dark or light; it just isn't. It gets harder and harder to believe in God, but more and more hungry to.'

Henri Finesse, he now is, in 1976 and 1977. He oscillates between the tripe and the divine. His pathetic pretentiousness returns with *My Armchair* (1976)—a wicker chair and pictures of his pictures, with a few Bonsai leaves chucked in for extra measure. It is clearly time to give the art a rest for a while, but suffering praise-withdrawal for Whiteley was harder than not scoring, not using.

When Brett Whiteley stoops to heroin and idiotic as well as bone-lazy collage, as in the later *River in Carcoar* (1977), that

old bad habits turn up to cruel the conjurer's pitch. In these lacklustre yellow willow trees juxtaposed against Reesesqué hills and Herald Outdoor Exhibition reflections of birds, that he seems to be another artist entirely, one impossible to follow because his judgement has truanted from the great original art school he once turned up first and earliest at.

Life, Death And The Other Thing (1977) won Whiteley the 1978 Archibald Prize (his second in two years) for the bizarre portraiture it really is. It depicts the artist in a blur of childish hand-painting in a frenzied sort of Expressionist facial and body image that is a homage to heroin addiction as well as anti-realism. His face is barely recognisable, this much-painted and sketched face has become distorted because he needs to show the conflict as well as the anti-balance and anti-rendering of skills both cast away and retained in order to make an emotional portrait, which it is because he looks out of his mind in it, and possibly is. He's very sick doing it.

For many years he was style and dexterity on tap, and like a medieval artist who knows his jars of paint powder off by heart, remembers in an instant just where this or that hoghair or red sable brush is, just where the turps or varnish or stand oil or cigarettes or whisky are, all of a sudden in this altered state which is the distortion he longs for he chooses to paint his agony front on rather than hand in another pretty romantic picture.

It is an honest and excruciating picture that is harrowing for the simple reason that all reason, and balance and har-

monics of this or that sweep of brush or prancing line, are given over to a contained piece of screaming hysteria. The hysterical screaming baboon reappears and the little cheerful earlier photograph of the artist as a good looking young man attached to the upper right side of the picture haunts the viewer also because it shows you what has been lost on the path to true disaster, true heroin craving, old addictiveness and abandoned longing for cure or the dead art of hope. Indeed it is a hopeless picture. It is remorselessly courageous as well as completely truthful in respect of the condition or conditions the artist is experiencing both at the moment of creation as well as the moment of departure, departing from old artifice and old style of spontaneous decorativeness for which he is a household word, and moving ever onward into insanity or great horrifying sickness. It is deathly-good.

No wonder this work beat everything else in the big prize in 1978. It stands out like dogs' balls from the rest. It is unafraid to show heroin addiction and unafraid to honour distortion. In it you easily see the reproduction of Joshua Smith whose portrait by the doomed Dobell won the 1944 Archibald and then there was the famous dispute over whether or not that picture was caricature or real; and in the end poor Dobell wound up in a farcical court case upon the matter of false or actual representation, and obviously Whiteley briefly identified with him.

This odd and captivating work captures quite uncannily the sense that both life and doom are cooperating in a lethal

experiment that closes both of them down simultaneously. Doom vanishes immediately the viewer considers the artist Whiteley in the cheery picture photo above the violently expressed self-image that is almost out of control, and you find yourself feeling the irony that he who was once so free and happy and charismatic is now enduring a trapped-in-oil paint panel servitude. He becomes a future shock and frozen inmate where the only cell door that opens is the honesty that he is truly an addict. There's no sympathy for himself in this brave picture. He wins the prize for guts because he has come out.

Sometimes in his work there is smirkiness and a smartness that is satiric and it can be crass and vain, but in this uneasy portrait he hits right in the main artery the human degradation and soul-indebtedness lost to the inhumanising drug that is heroin. That artery being his genius. He is a genius at several things in this particular picture.

To gaze upon its uniqueness and try to nut out its many sensations is to understand just how unravelled he was becoming at the time of its composition or his decomposition. So many times has this artist studied his old face and old body and sometimes naturalistically chronicled its earthly appearance and disappearance, and other times he has chronicled his eyes in a particular way, just as Vincent Van Gogh did when he went Oriental during his own foray into all things Japanese.

Here, in *Life, Death And The Other Thing*, Whiteley pays due tribute to other artists, as he always has, but the main difference is the new mood. The feeling of the work is supernatural and

haunting, it is a very frightening painting, if you like, because it is so ruthlessly soul-searching as well as comically playful, as though the artist is offering the viewer a unique chance to overdose on heroin with him, as if the fear in the artist really ought to be shared; perhaps that is art's aim? Oscar Wilde once said art's aim is to reveal the art and conceal the artist, which was pretty ironic coming from an egomaniac like him, but in this picture by Whiteley art's aim is to frighten, to jolt, to hit back.

When you think about the amazing output of Whiteley (he painted and drew for forty-six years), all of the works— the vast mural-like paintings, the 'American Dream' panels that are so big they nearly killed him, the drawings in Indian ink that are so complex as well as intricately interwoven like atomic-bomb spiderwebbery—you think of the gigantic canvases in galleries around the world. The way he attacked the bouncing canvas was like sheer pugilism—he counterpunched against the gurgling turps—you have to say he gave a lot of pleasure to a lot of people. What an entertainer he was!

The folios of sketchbooks are a boundless legacy of love for the most elegant medium in his life—that of drawing. His obsession with circumlocution was the same way he applied his arm and brain to mixing up colour, spreading the word of life-affirming colour to the darker reaches of his depression, which he always suffered from and battled against with fevered impatience. Impatient to show the viewer just how it feels to die, just how terrible it feels to be so famous, how awful it

feels to be mocked, how unjust it is to have to take heroin in private when it is only a mere sickness anyway, no different or less treatable than alcoholism.

There is a locked-iness about *Life, Death And The Other Thing*, in the strict mathematics of its logic and the planes of deliberate distortion. William Dobell was driven out of his wits as a result of his persecution led by Sir Garfield Barwick back in the days of his trial by caricature, in fact he lost the hearing of one ear due to his nervous collapse, he went bald and had to be hospitalised due to the running stress. Whiteley feels similarly pressured in 1978, he always did feel pressure because of his over-excitability, .which was perfectly natural, and he came down with drinks and drugs in order to handle his soul. In this picture it appears likely his own soul is in jeopardy. When you study the manner in which he has painted his own face, it is done with a breathlessness that is rather like the way a child would attempt to use scribbly face paint on a hot day. As always the style is Ala Prima, the old love of spontaneity. It is in fact a periphrastic picture with contradicting edges and endings in both the work and the meaning. There is the real sympathy for William Dobell and then there is the crucified quality of his own self-realisation through the beauty of his suffering and inner havoc.

For someone as famous to come out and own up to his addiction is admirable and in his case very necessary because always the true artist soul-searches, in the way that navigators used to cross uncharted oceans, with honesty and courage and

144

truthful ruthlessness. It's the only way to bear appalling, unforgiving, always-in-your-face life.

10

I'm having a telephone conversation with one of the last people to see Brett Whiteley alive. He is a reformed addict and, just like Vivian Whiteley Hopkirk, runs everything into the one big tale, as if all times past are all occasions present. It's all now. Everything is now. Right now. To make everything more dramatic everything has to be said at once. This is like the *alla prima* manner of living and painting that Whiteley followed all his days.

Michael Saker's manner and voice show excitement and experience thinned together with an affableness and an eagerness, a compulsion to speak in order to be with his old companion again. And it's very clear that he wishes things were very different, that his old mate was back. He asks me how I got his number and who I am—or rather who I was: he keeps saying 'Who were you? Who were you?' So I tell him my name and tell him I want to write a good book that discovers, uncovers, Brett Whiteley—warts and all but with affection. He says 'It's about time someone said something good.'

a funny kind of last hug

'It's interesting. I worked long hours in Kings Cross. I used to hang with him a lot. He'd go to me just like how people go to the pub, like buying a beer.

'I was quite fucked off with Wendy for a while and over the action against Janice. His name comes up and it blows her mind. People know her. My experience with her is that she's very much a bully. Janice was paid a thousand bucks to stay away from Brett.

'It's hard to talk about Brett without being very upset. A lot of him was fabulous, quite fabulous. He did things for me, quite a lot, when I was sleeping in a squat in Woolloomooloo. He used drugs to bond quite a few friendships. I gave up drugs. And selling them. I ended up using a lot of coke—it was pretty concentrated, wrapped up in ten and fifteen mil. When I was pretty sick he wrapped me up in a blanket, and he was really like he saved me. He could be very kind.'

There's all kinds of kindness. Is this the last kind?

'He stuck me in a car and took me to detox. He wrote references for court. Same day as Wendy went to court. He used a green Texta with which to write these references.

'He cared a lot about a lot of things, especially his concept of God. One day I was painting a coffee shop (I'm a painter too) and he sat in his car and looked at me painting the shop all day. An 89 Merc, he was in.'

I've never heard anyone string thoughts and memories and feelings and sensations together faster. I ask Saker if he's ever been interviewed about his past, to which he says: 'Brett was always writing out these character references for me. God they're invaluable! Brett'd say "I don't know what the cops have got against Mike, but he is of good character." And then he'd sign them with a flourish. A cop once said, "I'm not going to put you in jail, Michael, but I do want that reference." Out of the blue they'd ring him about me and Brett'd say "Oh, he's an artist." To them you're just a burden, to the police you're just a burden. He got off himself a few times. He could always get himself off.

'Did he listen much to me? He was a great listener and a patient listener. He liked girls, the ones that were coming round to my place when they were very young. In Darlinghurst this was—it was a bit of a community centre. I had taught a little bit of art—I was a primary school teacher.'

Really?

'This community centre used to be called "Suicide FX". Brett was never really patronising, and for years before he died

he'd say hi to me, and not just for the chicks. In later life he must have felt he'd lived his life a hundred times.

'He would repeatedly say he was a bit of an existentialist and did not feel bad about leaving the scene. We had huge feelings for one another. I used to say "You have to externalise your ego. You had to be melted into you. It was you talking to you and not God."'

'When did you last see him alive?' I ask.

'When he left Thirroul. I saw him just before that. When he left the video shop, and the bottle shop next door to it, the Corner Hotel it was. He wildly threw his arms around me. It was a funny sort of last hug. He had been hassled to get a video back and he got a late fine after he died. But he was dead, so couldn't he pay it.

'He wanted to rock up Gosford way, get really pissed and sit in the bathtub all day.'

Sounds great—I need that. But I don't need to be dead.

'He threw his arms around me and said he'd completely seen God. He was straight. He had three grams on him when I last saw him. When he died that night I wasn't real happy. I was having a coffee with my dog. This fucking guy from Channel 9 came around and thought I was his fucking art dealer! That's how I found out he was dead, that fucking Friday afternoon.

'I was tempted to believe there was no heroin on him. Maybe he took it all. They said there was no smack in his system, but why would he leave it in his studio? Mixture of pissed and taking pills. Wendy insisted no dope. People do die accidentally.

'This guy could come around and buy half a gram, belt them up, ten minutes he'd keep going. It's hard. He was concerned about a lot of other things. People who were outside everything impressed him. He could really get under your skin. When you had trouble, he'd say "What can you do to resolve it?"

'He relapsed with Janice. He relapsed with the oldest serving chick in NA.'

I ask 'What was she like?'

'She was fit. She swam a mile a day at the pool. We used to tell her, "C'mon go to six form tech!" Anyway Brett eventually got going with Janice. To a guy in his fifties, she was really helpful, a good thing, really friendly. To the friends she used to hang with, she was a little button-goddess. She got crushed by the family. Janice's dad died when she was going out with Brett. She somehow she got a Honda—an ordinary Honda, not the top range—and a one bedroom flat. The big rumour going round was that Brett was buying it for her.'

I feel like I'm listening for the first time in my life to the living truth of his death. This man's been down so long that just the chance to remember another man he liked and trusted is everything for him.

'Arkie was big time hassling him to pay for her boyfriend. He was the guy who saw the Will but couldn't find it. It was obvious that Brett was going out with a younger Wendy.

'About the Aboriginals and their land rights, he'd say, "I'm not going to give them my fucking house, man. They sort

of deserve everything else." When he wasn't tortured, he was surprised that he ever was. He was surprised that he wasn't tortured. Brett loved to ponder, he would fucking ponder.'

I'm starting to ponder too, what it is exactly that I'm hearing. Is this language, is this history? Is this true? Is he pulling my leg? I don't think so.

'He would just stop and think about it, whatever it was. He'd say, "Gee I'm sweating a bit, is that withdrawal?" He loved young girls under twenty. I said "How many young girls go to art school so they can fuck you?" He would be so happy when someone sucked him off. He'd laugh like a little kid.'

I'm completely nauseated—but riveted, of course.

'He was really intrigued by nature, you're right there. Interesting girls, he liked too. I never procured chicks for him. I acted as a conduit for a lot of young people. He frequented only the pulse. He was always on the razor's edge. He'd take me over to Lavender Bay sometimes to partake of the boredom. Wendy would entertain fucking pricks from Liverpool in England, and they'd say to me "Oh you're Lebanese!" Brett'd say, "I'm bored, you come with me." He had a hole at Lavender Bay to put the heroin in so he didn't have to pay any tax on it.'

Now that's about the best quote I've heard so far. But did he mean money or heroin in the hole? Did Whiteley deal in heroin? Michael is gone from the line now and my investigation for the moment is over, assuaged.

I sip a stubby under the apricot tree and look at the washing on the line. My God, what have I been listening to? I'd

say it's real comic tragedy, that's what it is: plenty of jokes and plenty of shame … and Brett Whiteley at the end not coming out of it with any sort of grace. How grotty it all got.

Where did it go?

To move into the Chelsea Hotel was also to move into high-speed relationships and speedily groped-for cravings for drugged-loving-seeming shoulders, anonymous arms and hatred that arrives from natural suspicion. It's not so much how you are going but how many you are going through— both drugs and intimate spontaneous sexual strangers. Brett did not use heroin in New York but approved of and got stuck into everything else. Reading R. D. Laing isn't a bad idea if you are having a splitting headache or enjoying a bout of multiple-personality disorder. *The American Dream* picture (1969) has to do not with America but with his longed-for fantastical self-explosions within his insufferable high-speed incurable destructive boredom.

Off to Fiji in the stoned belief it is 100 years ago. It is Robert Louis Stevenson and orchids and Arthur Rimbaud and Charles Baudelaire. But it is drugs and trouble and deportation, quite the opposite of tranquillity. If lightbulbs are glued to feathers—is this Fiji? To state the medium of a work is oil paint and electricity, is this advisable or funny? Is his work coloured ink or done in Cinerama?

Saying, after creating the vast and implausible *Alchemy* (1972–73), that alchemy is created in order to see what does

not exist is merely pseudo psychobabble. Painting drugged and dead drunk is not interesting to anyone other than you, other than the elite few who are permitted access to the fevered addict hard at it in the slog of getting through not to the other side, but to the end of the case of drink. It's never the spirit world one gets through to, but rapid detox in order to see. Seeing straight could be construed as hallucinating if you alone watch it. His own handwritten notes glued to incomprehensible works aren't as well written as verses by illiterate schoolchildren.

It was preposterously tragic that when he became completely addicted to heroin the treatment centres he fronted up to forbad him to paint. Painting was glorious life to him; not to, or never again to, paint or draw with a black-lead pencil was to hop on the scaffold with his colleague in suffering Doctor John. In a very real sense the idiotic rehabs killed him by never permitting him to paint there.

Saying memorably "I wonder, if they ever jailed me, would they let me paint?" is upsettingly candid and unforgettably tragic. He was capable often of being forcefully truthful. Even when he temporarily got off the poison, he longed for it once more as he saw it as art's friend, art's arm, as it were; art's soul.

If a once-brilliant and insanely lauded painter enjoys sell-out shows and like a Czar calls the media to order and keeps everyone on tenterhooks and at more than arm's length in order to secure privacy but at the same time demands attention

and praise as if it is the very oxygen that keeps us buoyant bodily and drives our red bodies' blood, then he demands more privacy but snips off his pubic hair and adheres same to the picture of him at full worship—then that artist is as nutty as a fruitcake. And that is the fact.

The end of his life is a sell-out exhibition of uninteresting and totally predictable tragedy because it was always so obvious that the trail got wound up, the signals got lost. The energy left was merely the feeble need to unscrew whisky and get the needle operative, lie abed and finally die because life is too messy.

Eyes blurred, eyes milky with the great need to shut them, stop them looking at a self- portrait that's unpaintable, he is vaguely staring back at nothing and childhood all together.

He honestly believes that if he is off drugs he cannot paint again, so whack it in and get out of the unendurable day-light that only elongates hours made of billions of needle-pointing seconds. That old good feeling comes back again: heroin. Or methadone, is it? What does it possibly matter any more?

Blackness comes at the point of unscreaming, unremark-able horror.

Where did the fun go?